Lives in Transition

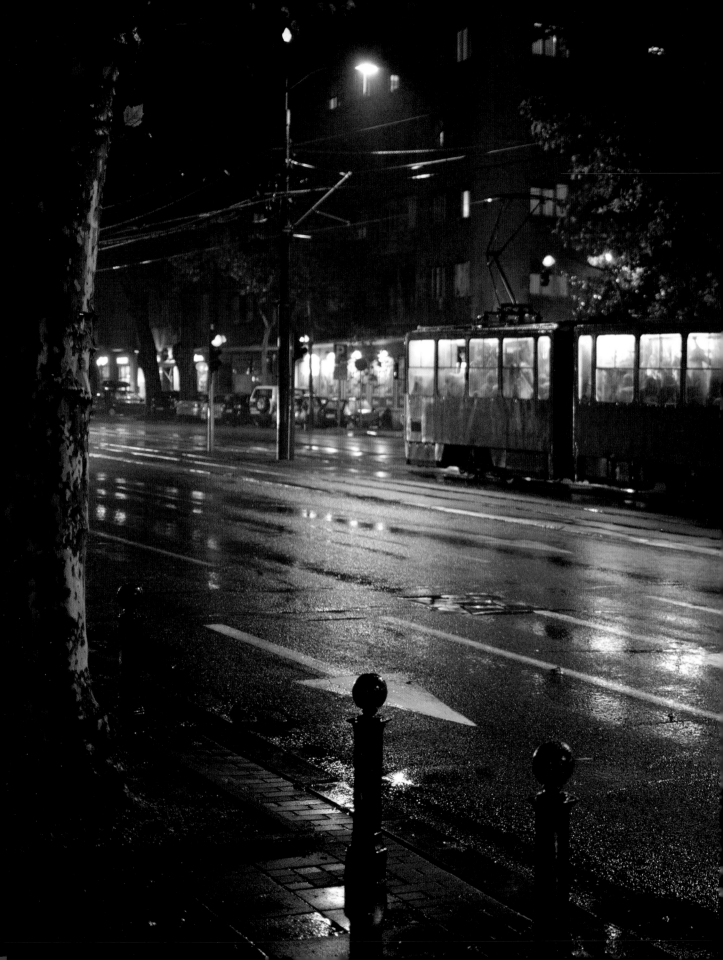

Lives in Transition
LGBTQ Serbia
Slobodan Randjelović

THE NEW PRESS

Requests for permission to reproduce selections from this book should be mailed to:
Permissions Department, The New Press, 120 Wall Street, 31st floor, New York, NY 10005.

Published in the United States by The New Press, New York, 2018
Distributed by Two Rivers Distribution

ISBN 978-1-62097-373-8 (pbk)
ISBN 978-1-62097-374-5 (e-book)
CIP data is available

The New Press publishes books that promote and enrich public discussion and understanding of the issues vital to our democracy and to a more equitable world. These books are made possible by the enthusiasm of our readers; the support of a committed group of donors, large and small; the collaboration of our many partners in the independent media and the not-for-profit sector; booksellers, who often hand-sell New Press books; librarians; and above all by our authors.

www.thenewpress.com

Book design and composition © 2018 by Emerson, Wajdowicz Studios (EWS)
This book was set in FF Meta, Franklin Gothic, Helvetica Neue, Helvetica Inserat, News Gothic, and Zapf Dingbats

Printed in the United States of America

10 9 8 7 6 5 4 3 2 1

Preface
JON STRYKER

This series of books was born out of conversations that I had with Jurek Wajdowicz. He is an accomplished art photographer and frequent collaborator of mine, and I am a lover of and collector of photography. I owe a great debt to Jurek and his design partner, Lisa LaRochelle, in bringing this book series to life.

Both Jurek and I have been extremely active in social justice causes—I as an activist and philanthropist and he as a creative collaborator with some of the household names in social change. Together we set out with an ambitious goal to explore and illuminate the most intimate and personal dimensions of self, still too often treated as taboo: sexual orientation and gender identity and expression. These books continue to reveal the amazing multiplicity in these core aspects of our being, played out against a vast array of distinct and varied cultures and customs from around the world.

Photography is a powerful medium for communication that can transform our understanding and awareness of the world we live in. We believe the photographs in this series will forever alter our perceptions of the arbitrary boundaries that we draw between others and ourselves and, at the same time, delight us with the broad spectrum of possibility for how we live our lives and love one another.

I am particularly happy to have Slo (as Slobodan is known) as a collaborator in *Lives in Transition*—as he is also my husband and partner in life! It seems like a daily occurrence that I see and learn more about the world through his lens. Like the other photographers in this series, Slo is, in his work and in his way, a great communicator, translator, and facilitator of understanding among people. ■

Jon Stryker, philanthropist, architect, and photography devotee, is the founder and board president of the Arcus Foundation, a global foundation promoting respect for diversity among peoples and in nature.

Introduction

PREDRAG AZDEJKOVIĆ

We Serbs have a long tradition of not knowing where our country stands. Is it part of the West or the East? Where are our borders? Are we friends with the Europeans or with the Russians? We don't know. We want to be everything and everywhere. We want to be part of the West and part of the East; we want the borders from our Serbian nationalistic dreams; we want to be friends with both the Europeans and the Russians; we want to create our own reality, and we expect everyone else to take part in it. But we also don't want to choose. We don't want our dreams crushed. We don't want to face reality, and in the meantime we wait for someone to rescue us from the injustice of that reality. Nobody is coming, but we still wait. Similarly, the LGBTQ community in Serbia is also waiting for a savior—waiting, complaining, and doing nothing.

Sex between men was long prohibited by religious law, and for almost three centuries, starting in 1459, when Serbia was under Ottoman rule, sex among men was seen as a foreign vice often attributed to the Turks, who were thought to use it as a means of humiliating their captives. After Serbia overthrew their Ottoman oppressors there were two brief periods when sex among men was not explicitly illegal, but after 1860 it was made punishable by up to two years in jail. In the twentieth century, when Serbia was part of the kingdom of Yugoslavia, then one of the socialist republics of Yugoslavia—together with Slovenia, Croatia, Bosnia and Herzegovina, Montenegro, and Macedonia—homosexuality remained illegal, although the law was mainly used to blackmail gay men into being obedient to the communist regime or to recruit them to be informers for the secret service.

In October 1990, several lesbian and gay people from Belgrade received a letter from Ljubljana (now Slovenia) informing them of the newly founded gay-lesbian Roza Club—the first of its kind in this part of the world. This letter motivated them to gather at the pastry shop of the Hotel Moskva in Belgrade and start organizing a gay-lesbian movement. After several meetings, they formed Arcadia, an informal group that could not be registered at the time because sex between men was still a criminal offense. Arcadia made an effort to involve people who actively participated in public life and advocated for human rights and political freedoms, and by focusing on condemning nationalism and militarism, they established connections with the pacifist and feminist movements. In 1994, homosexuality was decriminalized in Serbia and Arcadia was registered as the first gay-lesbian organization there.

As the war in Croatia and Bosnia turned against then president Slobodan Milošević, there was growing political unrest in Serbia itself. The opposition started a campaign against the dictatorial and anti-democratic regime, and with the help of state-controlled media they were labeled as traitors and foreign agents. The state-sponsored media attempted to use Arcadia to link the opposition to homosexuality, while the opposition drew on all its homophobia to deny the allegations. The gay-lesbian movement remained untroubled by accusations that it was treacherous and anti-Serbian, especially because of its strong anti-war, anti-militarist, anti-nationalist, and pro-feminist policies.

During the war years, from 1995 to 2000, the gay-lesbian movement was mainly focused

on anti-war activities. Some lesbians decided to leave Arcadia and form a separate lesbian organization, Labris, which started publishing collections of poetry and a lesbian fanzine and is still very active. Meanwhile, the first gay website came to life, Arcadia started its Campaign Against Homophobia, and the New Age-Rainbow organization was formed in Serbia's second-largest city, Novi Sad. On December 29, 1999, however, the founder of Arcadia, Dejan Nebrigic, was tragically murdered on his twenty-ninth birthday by his ex-lover. Dejan was a controversial figure for his over-the-top behavior. He was the first and most prominent gay activist in Serbia to publicly speak about homophobia in Serbian society and appear frequently in the media. Starting in 1998 he was the director of Arcadia's anti-homophobia campaign and editor of several reports. He became the first person in Serbia to file a lawsuit for threats to his personal safety motivated by homophobia. It was against the father of his ex-lover who later murdered him. Dejan's legacy lives on to this day.

The period after the year 2000 was very fruitful for LGBTQ activism in Serbia. In Serbia, there is a saying: for every two Serbs, there are three political parties. The same goes for the LGBTQ movement: for every two LGBTQ people, there are three LGBTQ organizations. New organizations were formed, including Gayten LGBT, Deve, Safe Pulse of Youth, Lambda, the Gay-Straight Alliance, and Queeria LGBT, the first and still only group in a political party. An international gay-lesbian conference was held in Novi Sad, a queer festival was started in Belgrade, and there was public debate about same-sex marriage. The gay magazine *Dečko* (Boyfriend) saw its first issue, and gay and lesbian websites proliferated online. Optimism was in the air after October 5, 2000, when Milošević's regime was finally crushed. We thought we were now living in a new world liberated from homophobia, violence, war crimes, and poverty. In this spirit, the first Pride parade in Belgrade was born, scheduled for June 30, 2001.

Today, almost seventeen years later, I can confidently say it was the biggest mistake the Serbian LGBTQ movement made. We, as an LGBTQ movement, and Serbian society in general were not ready for it. Right-wing extremists, nationalists, neo-Nazis, and soccer hooligans all came together against the LGBTQ community. The new democratic government had neither the power nor the will to protect us, because the influence of the old regime still lingered, especially among the police. Only two days before the parade, Milošević was arrested and sent before the International Criminal Tribunal in the Hague, where he was tried for war crimes. Many were angered by what they saw as an act of treason by the new government, and the parade was the straw that broke the camel's back. Everybody knew about the potential threats, but the organizers refused to cancel or postpone the event. The images that came from the first Belgrade Pride parade were scenes of bloody violence in the city center. Hooligans attacked anyone they thought looked gay or lesbian while the police calmly looked on without interfering. Then, with no one left to beat up, the hooligans turned on the police, which is when they finally reacted.

By standing back, the state had sent out a clear message to Serbian society: "Beat up the gays. We won't protect them. We won't react."

On the other hand, the violence was broadcast around the world, which resulted in a huge influx of donations to LGBTQ organizations in Serbia. The threat of violence made it almost impossible to organize a Pride parade, but in what became the golden age of Serbian LGBTQ activism, the queer rights movement made it the focal point of their work.

In 2009, after several unsuccessful attempts, several organizations—Labris, Queer Belgrade, Queeria, and the Gay-Straight Alliance—started preparations for a Pride parade. Homophobe extremists started their own preparations for a counter-parade. The European Union and the United States pressured the Serbian government into guaranteeing that the parade be held without violence, and the parade became a prerequisite for integration into the European Union. It became one of the most pressing issues in Serbian politics. Everybody had an opinion about the Pride parade—the pro-EU and the pro-Russian politicians, celebrities, activists, and priests. The fact that Pride was about LGBTQ rights, and not about the Serbian Constitution, freedom of assembly, EU integration, or Russian president Vladimir Putin, seemed to get lost in the debate. With all the pressure of politics and violence, LGBTQ activists started fighting among themselves, and in the end some of them, such as the Gay-Straight Alliance, were kicked off the board of the parade, and others, such as Queeria, left of their own accord. The LGBTQ movement was in a weak position in relation to the government and the police, and negotiations about whether the parade would be held in central Belgrade led to a stalemate. The organizers then announced to the Serbian public and to the world that the

government had banned the Pride parade. The parade's main organizer, Majda Puaca, who had been repeatedly threatened, left the country and received asylum in the United States. Despite the setbacks, this was also a period that ushered in new LGBTQ organizations, such as the Gay Lesbian Info Center and Egal; an international queer film festival, Merlinka; a new gay magazine, *Optimist*; an LGBTQ safe house; and organizations advocating for registered same-sex unions (same-sex marriage is forbidden by the Constitution) and gender identity laws.

The next year, a law protecting against discrimination based on sexual orientation came into force. This was also a requirement of the European Union, but because of pressure from the Orthodox Church, any homophobic statements made by priests during their services were exempt. Discrimination on the grounds of gender identity was removed from the law, but still the new law was reason enough to try for a Pride parade, this time with the Gay-Straight Alliance and Queeria. President Boris Tadic met in June with several LGBTQ activists and publicly declared his support for the parade in Belgrade. Finally, on October 10, it went ahead.

Almost ten thousand police officers assembled to protect the participants from six thousand protesters who, frustrated because they couldn't break the police barricades, started destroying the city. The march went ahead. After speeches from officials and activists, the parade started, surrounded by three cordons of police, and after a short walk it was over, without anyone in the march being hurt. Meanwhile, 132 police officers were injured and 249 hooligans arrested, the majority of them not from Belgrade. This suggests that

the anti-LGBTQ protests were organized and coordinated, but we still don't know by whom, because Serbian authorities did not investigate. The media reports from the parade were mainly about the violence, the damage to the city, and the exorbitant cost of police protection. They weren't about LGBTQ rights, and many people blamed the LGBTQ community for the cost, the violence, and the damage to the city.

After the parade, the organizers fell back to squabbling among themselves. Activists from the Queeria Center, unbeknownst to the Gay-Straight Alliance, registered a new organization called Belgrade Pride and took over the Pride celebrations. There was a Pride Week, but the parade was banned by the police for the next three years. Further pressure from the European Union and the United States resulted in a Pride parade in Belgrade in 2014, which went ahead without violence. This may have been in part because a new government was in power. The Serbian Progressive Party was comprised of former right-wing nationalists who overnight became pro-EU liberals. Nonetheless, the media was still unfavorably disposed to the march, saying the cost for police protection (speculated by the tabloids to be more than a million dollars) could have been spent on sick children, among other deserving people.

Many still characterize the approval of the Pride parade as little more than a way of pleasing the European Union and the United States, but since then, Belgrade Pride has been held every year in October, still under the watchful eyes of several thousand police officers. In 2015, Trans Pride was held during Belgrade Pride to increase the visibility of the Serbian transgender community. This,

in turn, became Pride Serbia the following year, an event independent of Belgrade Pride, without the police, the politicians, and the paid activists from abroad. It focused on the LGBTQ community and their rights, but many saw it as yet another division in the Serbian LGBTQ activist movement.

In 2017, Ana Brnabić became prime minister. She is an out lesbian, and her appointment, first as the minister of public administration and local self-government, then as prime minister, was a historic moment and made a splash in the news worldwide. Unfortunately, the victory has been largely symbolic, and her appointment hasn't led to any new legal protections for the LGBTQ community. At the same time, it's interesting that former right-wing nationalists now support this appointment, while the opposition has turned against LGBTQ rights because they don't know any other way to oppose the ruling party. Pink-washing though it may be, Brnabić attended the Pride parade as minister in 2016 and prime minister in 2017, both times accompanied by the mayor of Belgrade.

Now, every year we have Pride Serbia in June and Belgrade Pride in September, but fewer people are attending. We have a lesbian prime minister, but there have been few, if any, improvements to LGBTQ rights. Many queer activists have left the country and secured asylum abroad. Of the people who stayed, many are increasingly disappointed with local activism. Many feel abandoned and are sick of waiting for their savior. But we can't all leave. Some of us must stay and fight! ∎

—Predrag Azdejković, Editor-in-chief of *Optimist*

From the Photographer

SLOBODAN RANDJELOVIĆ

I have spent a lot of time thinking about the ways in which I should portray these amazing people and tell their incredible stories, and I have realized that, during my many trips to Serbia, I have become so emotionally attached to my "subjects" that it's difficult for me to portray them in an objective manner. I am telling their stories the only way I can, subjectively, from my own point of view, and informed by my own experience and history.

I was born in the late seventies in what was then Yugoslavia—a country in the Balkans with a troubled history of war and subjugation by foreign powers. My mother married my father when she was twenty and gave birth to an eleven-pound baby: Slobodan, which in Serbian means "free." There I was, destined to break the rules and be free forever. At least, that was the future she hoped I would have.

There were many boundaries for a child like me in Yugoslavia. I discovered very early in life that I was, well, "different." I did not like to play with "boy's" toys, I did not like "boy" colors, I did not like to play sports. But I did like to sneak into my aunt's closet when no one was around.

I was obsessed with my aunt; I loved her to death. There were times that my mom, desperate for me to stop crying, would take me to her parents' house in the middle of the night and pass me, a "little blanket-clad burrito," to her sister through her bedroom window. Then, she would drive home to catch some sleep ahead of her morning shift at the concrete block factory. In my aunt's arms, I was at ease, I was home.

The perfumed smell of her closet was intoxicating, and from around the age of five I would run my little fingers through her T-shirts, all folded to perfection, which she brought home from foreign countries, and her hair ribbons— shiny, glittery strips of woven fabric. As time passed, I became more adventurous. I started pulling things out, pretending I was wearing them, until one day I plucked up the courage to put on one of her skirts. It felt incredible, like a dream come true. I wove ribbons in my hair and wore white-lace fingerless gloves. This became my little secret ritual. I always tried to put everything back as I had found it, but she knew I was snooping around, and she never reprimanded me. Those were probably the happiest years of my childhood.

In our family, my aunt was the wild one. She was the competitive sky diver who wore tight leather clothes and rode a motorcycle. She started taking me everywhere, including her sky-diving training sessions, and sometimes, if I got lucky, nightclubs. One day, she asked me what color I wanted her hair to be. I immediately chose purple, and by the time I saw her the next day she had dyed her hair purple. She was my purple unicorn. That was the first time I truly understood that being different, being bold, was all right. I felt liberated. I was set free.

Not so at school. School was tough. I was naive to think that in school I would be treated with the love, respect, and kindness I had known in my family. I was a savvy and inquisitive student, and throughout elementary and middle school I excelled in almost everything

I did—math, physics, poetry, theater. The only class I didn't like was PE. It made me feel uncomfortable to be in the locker room with other boys, and I avoided it as much as I possibly could.

What I was not prepared for was the bullying. One day—it was probably in second grade—I wore my sister's neon-colored socks to school. That was a bad idea. Older kids laughed at me, calling me the Serbian equivalent of "sissy," "faggot," "freak," and "homo," and other words that can't adequately be translated into English. I didn't really know what most of them meant; I just knew they were all bad. I cried, I didn't understand why they hated me so much. Some of those kids didn't even know me. After this happened a few times, I learned how to shut myself down, disappear, and blend in. It was suffocating, but it seemed to be the only way for me to survive, and I learned to avoid being bullied.

I focused on studying. Everyone in the family thought that I should become a doctor, and one day my aunt gave me a three-volume medical encyclopedia. It looked expensive, and I was sure she had spent half of her salary on it. I started reading it immediately. Weeks later, I hit "H" only to find "H" hitting me back: Homosexuality, it read, was a mental disorder that could only be cured through psychotherapy and electrotherapy. I was mortified. I was convinced I was sick. At that point, I knew I was a "faggot"—one of those people everyone mocks and happily says should be impaled, burned, beheaded, put to death in the most violent way imaginable. I always

thought that I was the only one and that I should keep it to myself forever. There was no Internet, no TV shows, no literature, no magazine to tell me otherwise. I was twelve years old, and I felt like my life was ending.

I was determined to cure myself. I started practicing karate. I was pretty good at it, and it made my father proud—his boy was manning up! I also really liked it. It was an individual sport, and I could focus on results without involving team members or friends.

There was a boy in my class who was much more advanced in rank. We went to the same school, we were the same age, and we were perfect sparring partners in karate class. I was dating his sister, but other than brief interactions during training, we never socialized. One day, during a lunch break, he approached me and started chatting—the kind of small talk when you can't think of what to say. I couldn't figure out what he wanted until, looking into my eyes, he said, "See those two?" pointing toward a boy and a girl, "You know they're dating, right?" I nodded. "You know, I've been thinking about this for a while," he continued, "and I was wondering, would you like to be with me in that way? Would you like to date me?"

I was speechless, my head was spinning, and I thought I was about to pass out. I felt like throwing my arms around him and kissing him right there, but instead all I did was say coldly, "I'm sorry, I am not like that." Without another glance, I walked away.

I wanted him so badly, but I was certain that he was just provoking me, trying to get me to

say yes so he could later ridicule me in front of everyone. He didn't take it well. During training, he became very aggressive with me. I didn't have the courage to confront him, and I left karate for good. That's when my depression started.

The war in Bosnia came soon after that. Yugoslavia was placed under a heavy embargo, and the political and economic situation quickly deteriorated. Like many others, my parents lost almost all their savings, and we suddenly went from living a middle-class life to living in near poverty. My mother understood that if she and my father stayed in Serbia, they wouldn't be able to support my education, and she found a way to move to Italy. My dad reluctantly followed. I stayed behind. I was sixteen, in high school. I had a couple of girlfriends I hung out with. I drank too much, and I was depressed. We would listen to the Cranberries, Sinéad, Nirvana, and Björk and drown our sorrows in my grandfather's homemade wine and rakija, which we stole from his cantina. We would get so drunk we couldn't remember half the things we did.

I was especially close to one of my girlfriends. I loved her with all my heart. We were the first people to come out to each other: I as a gay man, and she, well, it was a little more complicated. At the time, she told me she was a man "born into the wrong body." Later, she identified as a lesbian. She started a secret relationship with our closest girlfriend, which didn't bother me much at first, but after a while I started feeling pushed away. I became convinced I was being used only as a cover for her relationship with her girlfriend. I was desperately lonely, and my depression kicked in stronger. At some point, I became suicidal.

The day on which I had decided to take my life came sooner than expected. I wrote a letter to my parents, wishing my loved ones goodbye. There I was, in my room, next to an aquarium filled with my beloved turquoise discus fish and my two parrots, ready to swallow the pills I'd stolen over a period of a few weeks from my aunt, who was a nurse. I was drunk. I was sad. I missed my mother. I pictured her as she was notified of her only child's suicide. Her father had committed suicide after discovering he had final-stage cancer, and she never forgave him. Would she forgive me?

In the end, I decided to live. I still don't know if it was because of my mother or because I was too scared. I realized that my life was mine to live, not mine to take. I promised myself that I would live every day as if it were my last. I also decided to leave this place, where because of my sexuality I was considered sick. I knew there was nothing wrong with me.

Fast forward three years. I was in Rome as a transfer student, in my second year studying architecture. Rome was an incredible experience: the food, the art, the architecture. I felt free. Italy gave me many things, but above all it gave me something I had never had before: a best friend, a soulmate, someone who really understood me. Patrizia was, and still is, the only person who saw me for who I was, the good and the bad. She is the only person who loved me wholly.

We shared everything. Her family treated me as one of their own. I will forever be grateful to her for giving me the strength and confidence to keep on going and for being there for me every step of the way.

I graduated, finished my master's in landscape design, and moved to Kenya, where I met some of the most important people in my life, including the man I married ten years later. My love for him took me across the ocean, to New York City. Life was crazy. Life was good. Life was everything I ever dreamed it could be. I didn't return to Serbia for almost twenty years. My life there faded into the background.

But, deep down, Serbia was still inside me, lurking in the darkest corners of my consciousness, gently whispering to me. I would tell myself that I needed to stay away. I would remind myself how I had been treated there.

I decided to take a year off from my architecture practice and focus on something else. The possibility of a book about LGBTQ people in Serbia arose, and I was faced with the prospect of going back home. I was committed to this exciting project. I wanted to meet these people, to try to truly understand them, to document their lives with open eyes and an open heart.

This project started in April 2016, and I write this in October 2017, a few days before I leave Serbia. During these eighteen months, I have met some of the most remarkable people, starting with Helena. I wrote to Helena the day after her gender-affirming surgery, and she generously let me see her in the hospital. In the months that followed, she accepted me into her life and introduced me to many of the people who appear in this book. I love them all. I care about them all—about their safety, health, economic security, and happiness. They have their flaws, as does everyone, but they are my people, my friends.

With this book, I hope to show a glimpse into their lives so that anyone who reads this can find empathy and understand that we are all human, that we all hurt, and that we all love. We all deserve to be treated equally and respectfully, and we all have the right to live with dignity. I hope that I brought something positive and productive to their lives, a glimmer of hope. They certainly did that for me.

From when I was that little person dressing up in my aunt's clothing, my journey has been long. It hasn't always been easy, but I have been fortunate. I have privilege that I have never hesitated to use, and I am using it now to make this book. This book is my gift to the people who, in these last eighteen months, have helped me heal emotionally and reconcile myself with the place that did not want me, that did not respect me, a place that never let me feel welcome, safe, or secure. For me, it is too late to return for good, but for many of the lesbian, gay, bisexual, trans, intersex, and queer people there, it may not be too late to stay. Hopefully, Serbia will learn how to embrace them and treasure them instead of rejecting them and pushing them away.

I live for that day. ∎

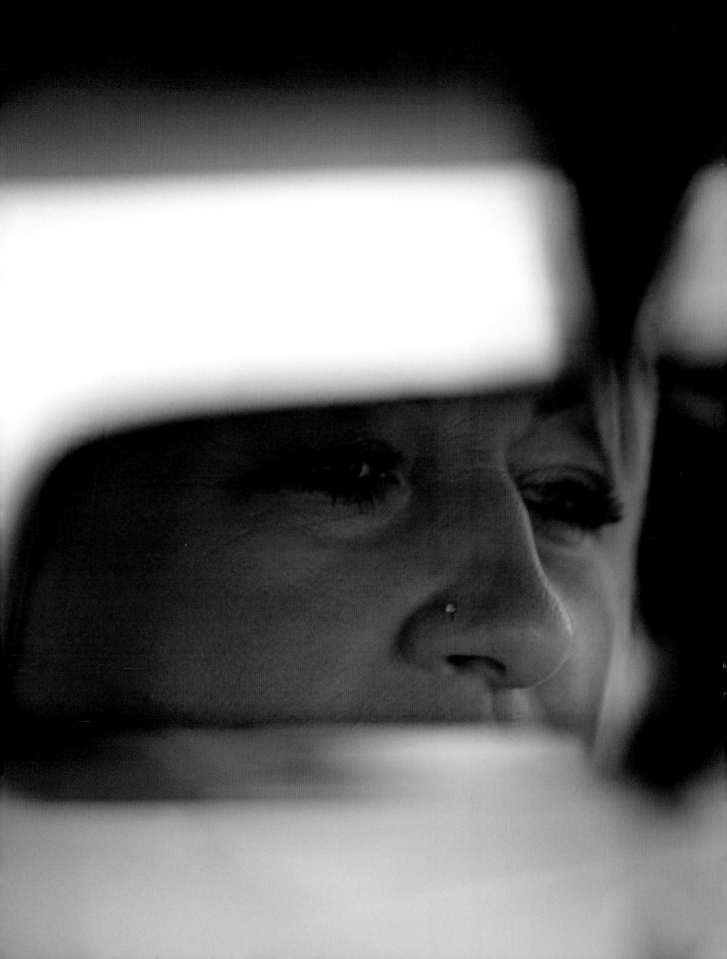

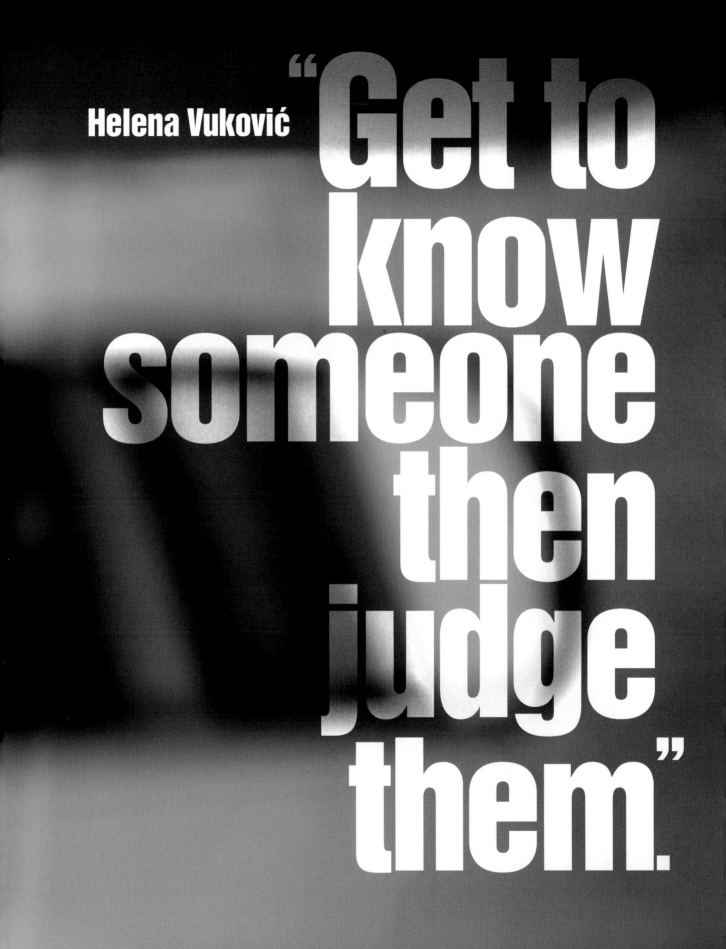

Helena Vuković

"Get to know someone then judge them."

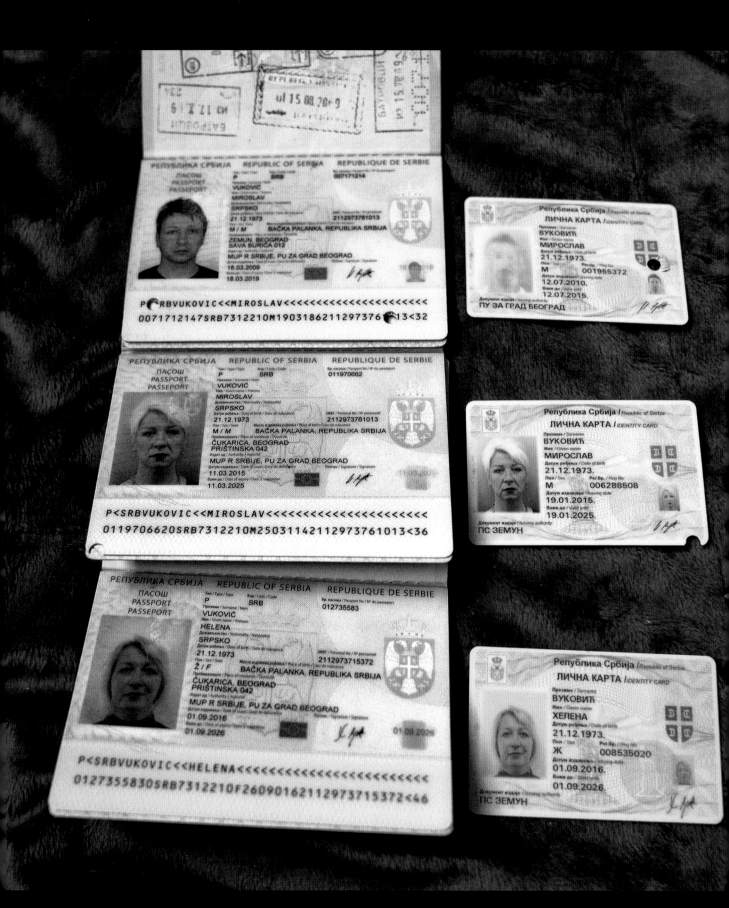

"I feel like a woman, I am a woman, but everywhere I go everyone sees me and defines me not as a woman but as a trans woman."

How do I self-identify? It's a complex question. I've always felt like a woman, and now, after finally physically becoming a woman, it turns out that I am a trans woman. I feel like a woman, I am a woman, but everywhere I go everyone sees me and defines me not as a woman but as a trans woman. Well, fine, but I am still a woman. In a weird way, I feel like I will never not be labeled, but what matters the most is the way I present myself and the name on my ID: Helena Vuković, a woman.

It's an issue even with my girlfriends. Everyone sees it as an exotic thing. It's been a problem with every woman I have been with. Their mother, even if they knew their daughter was a lesbian and they'd weathered that, they just wouldn't accept their daughter dating a trans person—it was total madness. My girlfriend, T, who was back home in Montenegro, told two good friends who she was dating, and one of the two was totally fine with it. The other one stopped talking to her and was very upset. She kept saying I will destroy T's life, that I destroy everything, including my own family and marriage. I always say, "Get to know someone, then judge them."

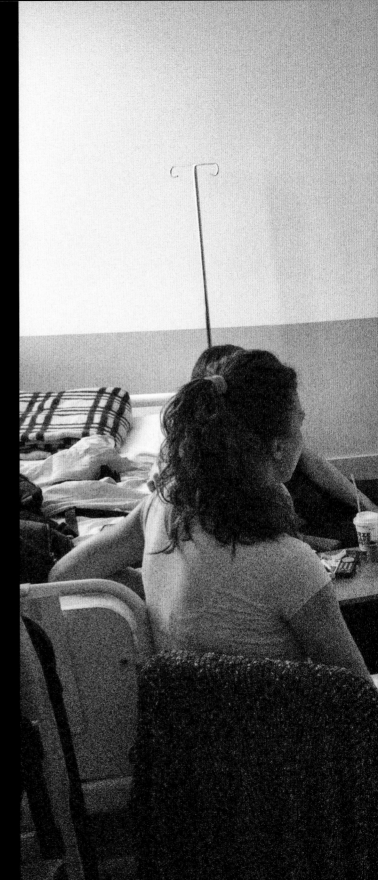

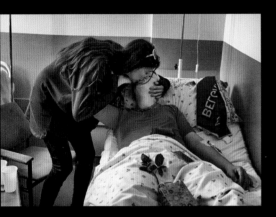

Helena, her girlfriend, Merlot, and the surgeon who operated on her, a day after her gender-affirming procedure.

In short, I am Helena Vuković, a woman who is not totally a woman because to my children I am still "Dad." The world may see me as a trans woman, but to my children, to my youngest son, Uroš, I am still his Dad. Uroš refers to me as male. All my four children do.

I think it's too much to expect them to refer to me as a woman. When you build something for more than twenty years and then it collapses like a house of cards, it's hard. Maybe if I'd done it a long time ago it would have been different. It's very hard for everyone, especially for the kids. I had repressed my womanhood for so long, and I was so afraid that I might be discovered. When it happened so suddenly —like a clap of thunder from a clear sky—when I was outed, it created so much resistance from my children.

I do feel guilt. But sometimes I think, what if I had died in a war, if I had disappeared? They wouldn't have their dad. They wouldn't have anyone in my place. They would only have memories of me. This way, they have a parent in their lives—a different person, but a happier person. This is what people don't understand. Gender doesn't matter. What matters is what kind of a person you are. »

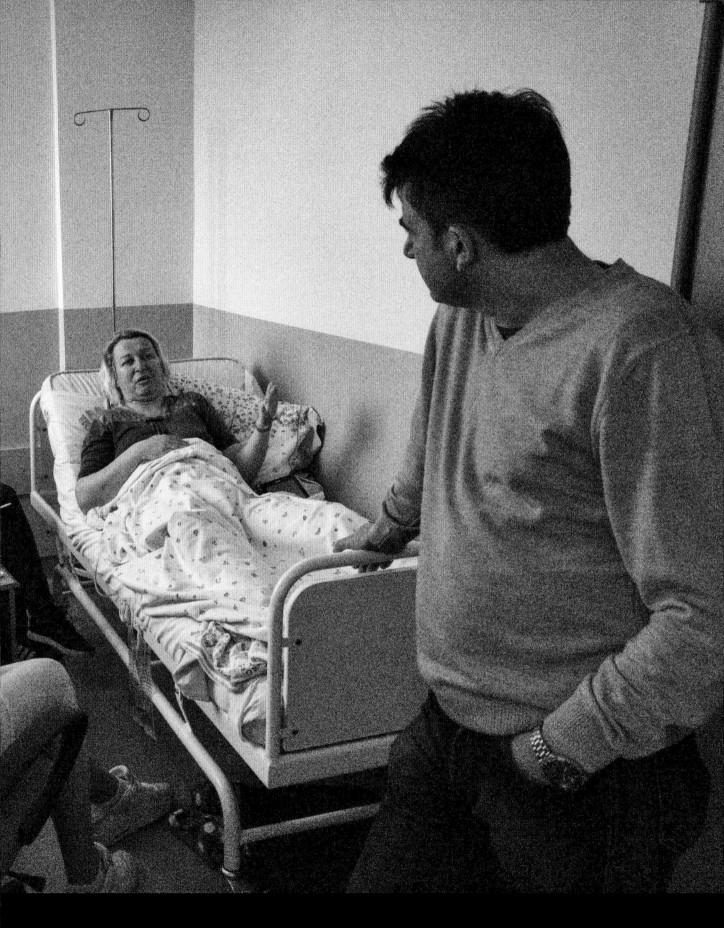

"It's difficult, and painful, to talk about this, but Helena killed their father."

At the moment, I don't have any kind of relationship with my oldest son. It's his decision, and it will always depend on him. I'm here and available. He's forgotten many good things I've done for him, but if I were to die now, I could say that I am proud of him and that I helped him become the man he is—a responsible, resourceful, and educated person who helps others, but above all helps his siblings and his mother. I succeeded where my parents failed. It's been eleven years since I've had any contact with my older brother, not by my choice.

Uroš is starting elementary school in two weeks. I've come to terms with the fact that I won't be there for his first day of school. I probably won't be invited to my children's weddings, or to many important events in their lives. Still, I'll at least have some information about their lives, and they'll know that I love them and that I'm here for them if they need me.

It's difficult, and painful, to talk about this, but Helena killed their father. You understand that? Try to explain that to a young girl, to an adolescent boy? It's hard to accept it. Being a trans person makes everything so complex. Like, when people tell me, "You're a woman now, why don't you like men then? Why are you a lesbian? Wouldn't it be easier if you stayed a man and had relationships with women?" People don't get it! People don't understand that sexual orientation and gender identity are not synonymous; they are separate things. I've felt like a woman my whole life, but I've also been attracted to women my whole life. I enjoy the texture of their skin, the smell of it, the softness of their bodies, the mental connection. With men, I can go out for a ››

drink, be their buddy, but I've never been sexually attracted to men. I experimented with men when I was younger. I experimented with my own body. I wondered what a woman felt having sex with men, about penetration. But I never really enjoyed it. Men are scruffy, rough. They smell different. I didn't like it. I've always loved women.

I spent years trying to understand who I am. I knew I was different, and at the beginning I couldn't really define it. At some point, I found this book in my uncle's attic, *What Teenagers Need to Know*, by Dr. Lombard Kelly. I looked at the glossary and discovered words like *transvestite* and *hermaphrodite*, which I didn't identify with. When I read the definition of *transsexual* I knew I'd found myself. That was me. At that time, no one was even talking about surgery. The first gender-reassignment surgery in Serbia was done in 1989. I remember reading the article in a newspaper and asking myself, "When will I be like this? When will I undergo the surgery?" It took me twenty-seven years to do it. When I was a kid, I remember hearing the stories that »

NIKADA NEĆE UĆI U NATO, JER JOJ TO NIJE POTREBNO • N1 • PODACI PORODILJA U RU

10:21 /

A birthday party for Helena and a presentation on a book about her life.

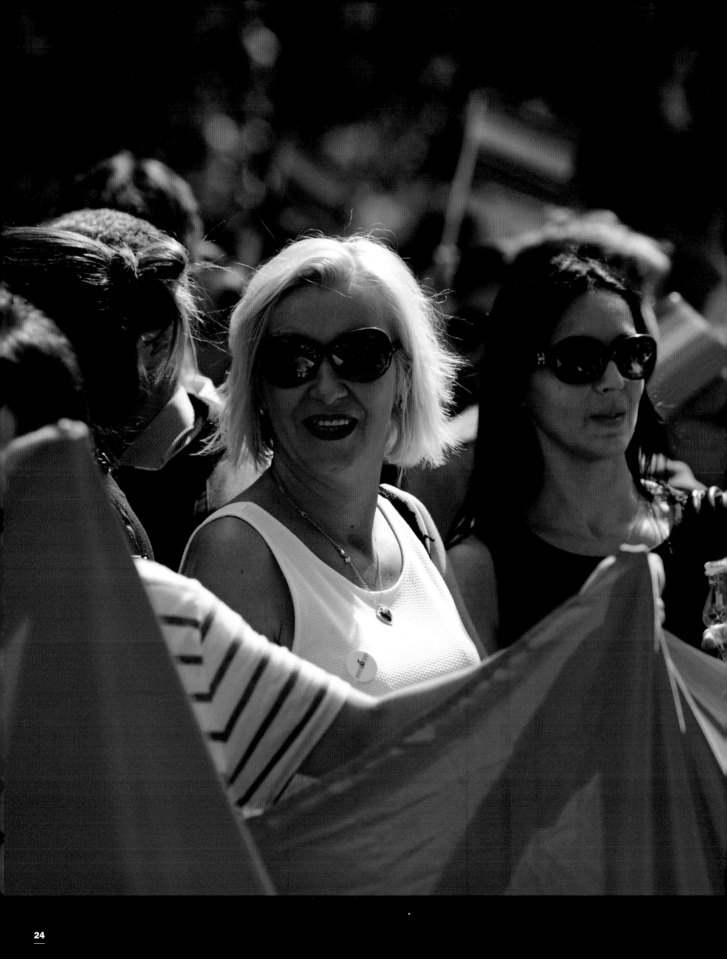

if you ran under a rainbow, you would become a girl. Needless to say, I tried to run under every rainbow I saw. I can't explain it to people who haven't lived through this experience, the amount of suffering, the amount of pain. The worst thing about growing up, when you hit puberty and your body starts to change, your friends' bodies start to change, and they start looking at you differently—not as their girlfriend anymore, but as a boy. They push you away. I was also never friends with boys. I didn't like to play soccer or wargames, so I ended up by myself, pushed away from both sides.

One of the hardest things was coming out to my ex-wife, that entire process, when everything in my life started to implode, to fall apart. It was a perfect storm. That was the first time I was faced with the consequences of my actions in such a violent way. I was living in a situation that had become unbearable and unsustainable. I couldn't live like that any longer, keeping it all to myself, so one day I just spilled the beans and told my wife. That was a psychological low point in my life. There was a period of total silence in our house. No one spoke. Total madness. ››

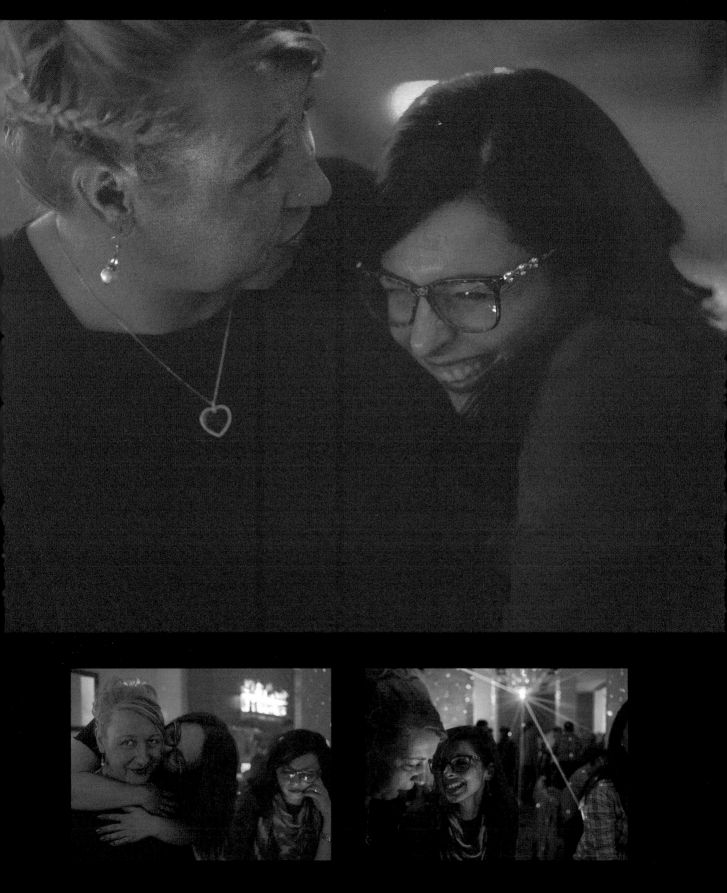

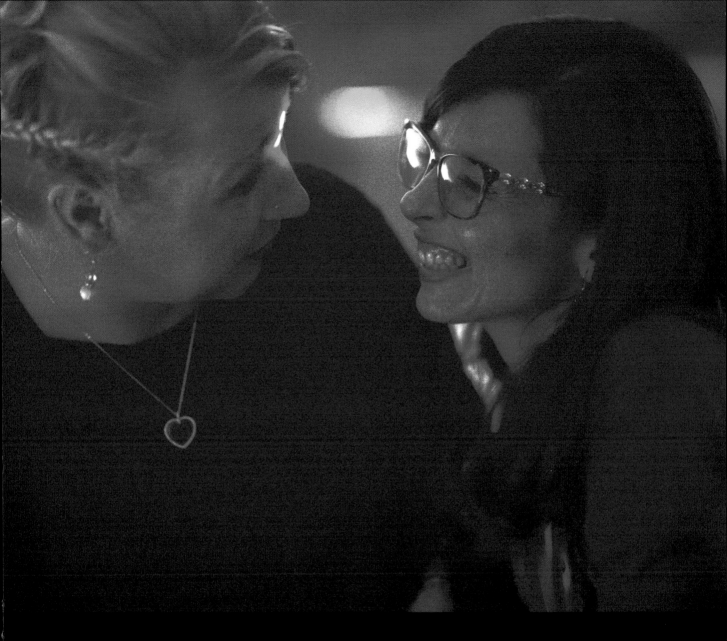

I hoped she would understand. I even offered to stay with her for the kids' sake, but she absolutely wouldn't have anything to do with it, so we decided to separate, and later to divorce. We decided she would keep the kids. She didn't believe that I would actually transition. She didn't think I was serious about it. She didn't believe it until the day of the surgery. After the surgery, two, three days went by without her texting or calling—total, deadly silence that really hurt me. It made me so sad that the person I'd spent twenty-two years of my life with ››

Activists gather at Helena's apartment a night before the June Pride parade to plan the event.

> **"I want to continue helping other people who've had similar life experiences, people who feel like they're different."**

could just erase me from her life. Then, one day I got a message from her: "Are you alive?" Just that. I responded by telling her how hurt and disappointed I was that she wouldn't even ask me how I was after all we'd been through together. She said, "And what am I supposed to ask you? I don't know what to ask you. I've spent all this time crying and rewinding the memories from our past, our lives together." She felt like a big chunk of our lives had been thrown away. We lived through too many things together, too intensely.

Now, a year later, things are different. She's supportive and caring. She got remarried and is happy. But she and I have four kids together, and our relationship will always be special. Always.

I see myself staying here in Serbia, unlike many LGBTQ people here who want to leave. If I wanted to leave, I would have done it a long time ago. I want to help others. Here, I am recognized, I have a certain status, and many people ask for my opinion or help. I want to continue helping other people who've had similar life experiences, people who feel like they're different. I want to fight for them so they can lead a normal, productive, and thriving life here in the »

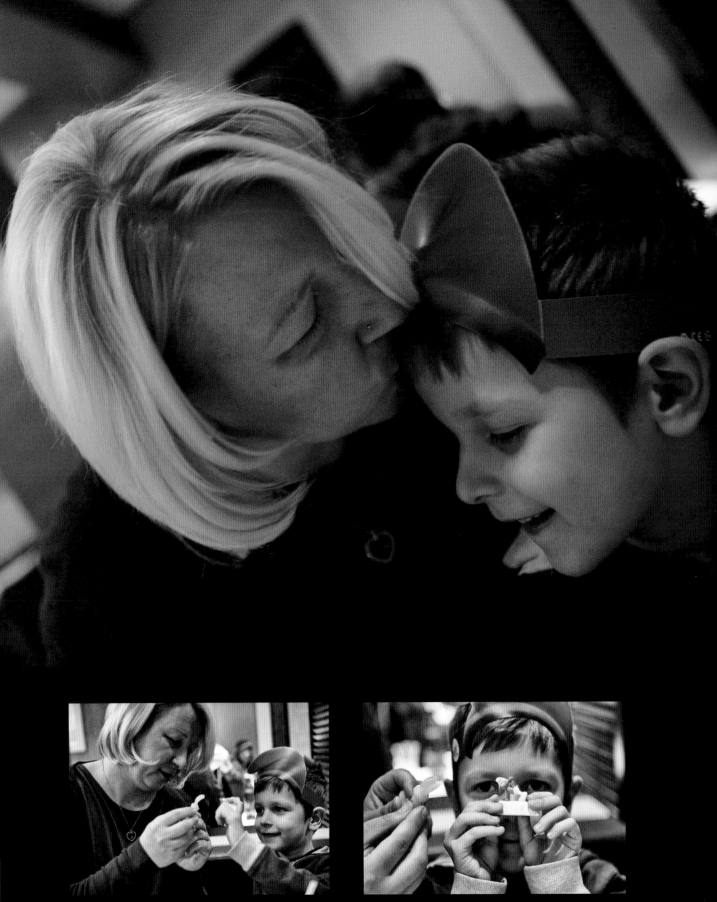

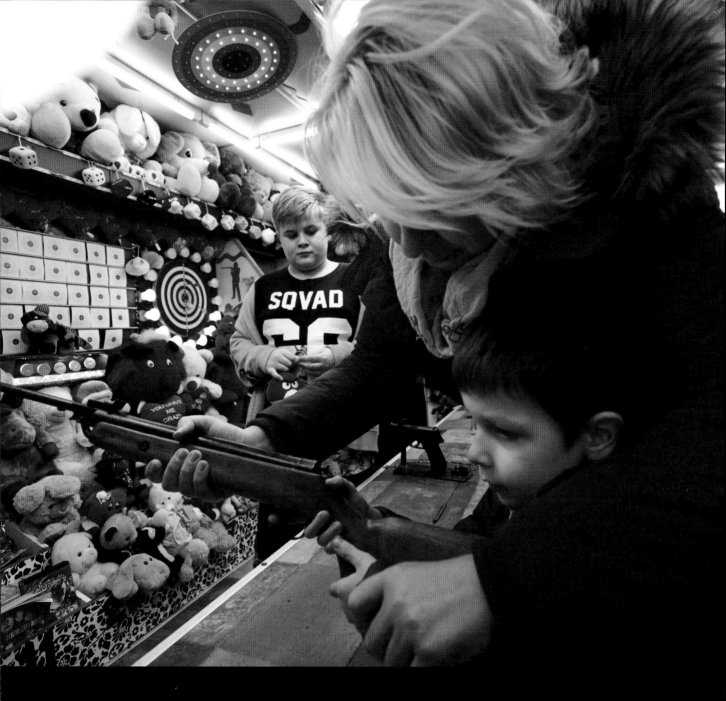

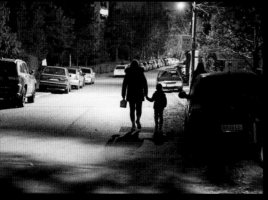

country where they were born, so they don't need to run away and seek asylum in foreign countries. I know it's a Sisyphean task, but it's my reality; I already live it every day. Sometimes it causes problems in my personal life, always answering messages, sometimes in the middle of the night. I don't have work hours; I'm always open to people, and I work from the heart. I know that people need me, and I try to give them my best, but it's not always easy. I'm not looking for special status; I don't care about that. If I were to die tomorrow, I'd know that I have already made history in this country. I don't ››

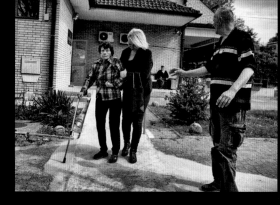

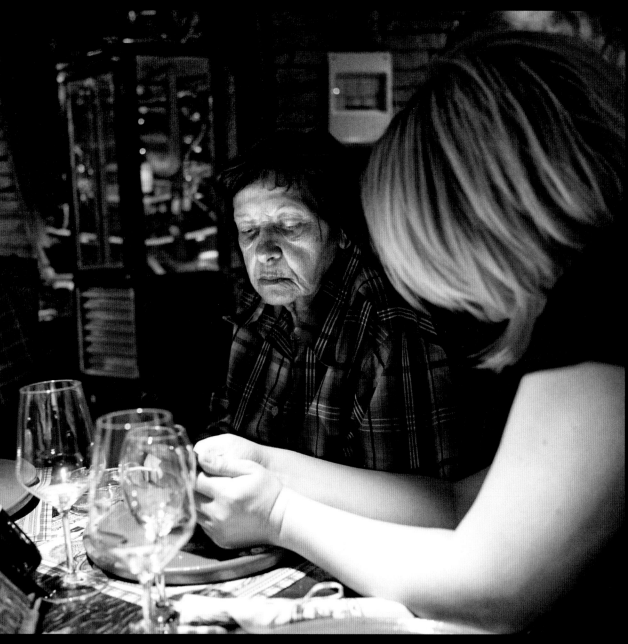

Helena visits her mother, Mica, in a retirement home. It was the last time Helena saw her mother before she passed away.

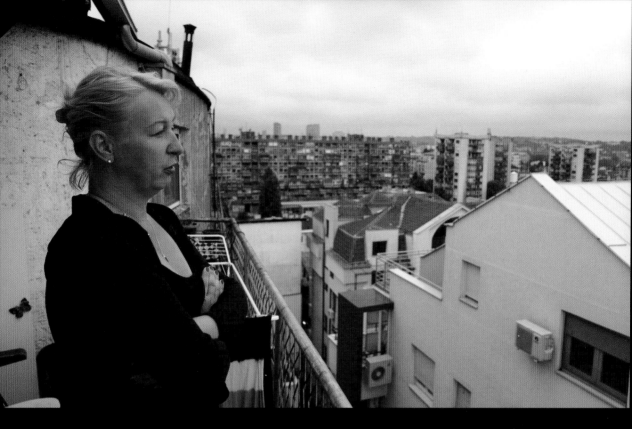

I didn't choose my gender at birth, but I can chose the gender I die with."

need more notoriety. What I care about is to have enough for my children and myself, for my partner, so we can live modestly but with dignity. I'm a modest person. The biggest things I bought for myself these last couple of years were a laptop, a TV, and an A/C unit. Until last year, I hadn't had a real job for almost two and a half years. Instead, I worked many different jobs—I cleaned apartments, I painted apartments. I'd tuck "the deceased" (my genitals) into my tights and go on. I was never embarrassed of doing any kind of work; any job can be done with dignity. Recently, after a year of working on a temporary contract, I was hired full time. It's a big deal for a trans woman. I feel a little safer.

Health is my biggest concern in the future—my children's health first, then my own. People ask me if I'm afraid of death. It's silly. Death is inevitable. I'm not afraid of death, but I am afraid of not completing all my goals in my lifetime. I often think of my friend Mariana Peron, who I followed closely during her transition in 2009. One day, I received a message from her: "It's done!" She was in the hospital and, finally, after years of transitioning, had undergone gender reassignment surgery. She was so happy; her life was just beginning. Nine months later, she was hit by a car and killed. She died young, but on her grave is her female name, Mariana, not her old name. It matters. When they asked me, "Are you afraid of the surgery?" I answer, "No, but I am afraid of not making it to the surgery, of dying before the surgery, that my name on the cross will be my old name." Then it would all be in vain. I didn't choose my gender at birth, but I can choose the gender I die with.

"In Serbia, there are many gay men who are wealthy and closeted."

Predrag Azdejković

I used to enjoy telling people upfront that I was gay. I liked to shock them. Now, everyone knows who I am, and I don't really need to say who I am anymore. Yesterday, I was returning from the airport, and a taxi driver asked me, "I recognize you. Did I drive you before? Are you from some LGBTQ organization?" I said yes, and he continued, "Yes, I remember you. Last time, you were all dressed up. Today, you look like an average person." I told him I'd been going to an event back then. Today, I was returning from a trip. He was a nice person.

I've spent so much time as an LGBTQ activist. The only problem with that is there's no way back. I can't put myself back in the closet. There's no undo button. It's like having my forehead tattooed with the word *gay*. I've just returned from a trip to Spain with a group of people, some of them Serbian, some Croatian. The Croatians didn't know who I was. I quickly became friendly with them. I didn't feel any prejudice, not even a remote possibility of prejudice, something I feel very strongly when I'm with people from Serbia, especially Belgrade. I didn't come out

"I love certainty, I love security, and I don't have either."

to them, and even if I had, I wouldn't have said I was an LGBTQ activist. As an activist, I often criticize the Church and the government, which makes me a lot of enemies. I don't make enemies because I'm gay, but because I have different opinions on the Church and the government and politics.

My boyfriend, Milanče, also identifies with things that are more important to him than being gay. He's a writer, a journalist. That's what he wants to be known for. He wants to be a writer, a journalist, and not a gay writer, a gay journalist. You saw what happened to our new prime minister, Ana Brnabić. Whether she likes it or not, they label her lesbian before saying anything about her work or identity. There was no going back. She was a lesbian who was prime minister.

I'm not a romantic person. I'm one of the worst people to buy a gift for. First, everything I need, I buy myself. For birthdays, I'm excited about the attention, the care, the thought someone puts into making or finding a gift, not the thing itself. It could be the smallest thing, as long as it's done with attention and thought. Otherwise, I just don't care. For example, Milanče knows that in September I'm going to a John Waters performance in Vienna, and he made me a T-shirt with a John Waters quote on it. That's what I needed! If I were living somewhere else, a less homophobic place, I might be more romantic, but here, I'm not. I define love more as partnership. We're two individuals who support each other. I'll do all I can to support him as a writer, I'll invest as much as I can in his career, and he'll do the same thing for me. We build each other up, and when I need him, he'd better be there to help me. We love each other and respect each other's choices and try to make each other better people. Support includes supporting things we don't understand. Many things Milanče does I don't understand, but I don't want to change him, to condition his interests or the way he sees

things. I want to encourage him to keep working on himself and become a better writer, a better journalist.

We've been seeing each other three days a week for more than eight years now. We work together, but we both like our time alone. We both say, "Imagine if we were living together all the time, we would go nuts!" If we had a much bigger apartment, maybe, but the way it is now, it isn't an option.

I love certainty, I love security, and I don't have either. I live from one project to the next. For now, knock on wood, everything is fine. I have a lot of projects I'm working on, but if one day the work stopped coming in, it would be very frustrating. I wish I were financially secure enough that if I weren't paid for my projects, I could still survive for a while. I don't have that. I feel like I'm living in semi-permanent precariousness.

I was left without a father when I was fourteen. He died of cancer. It was at the beginning of the war during the U.N. embargo. He was the breadwinner in the family and had been getting a German pension for years of work in Germany, but after the embargo was imposed, his pension stopped, and we were left with no money. None. Total poverty. That lasted for two years, until 1994, and I still carry the trauma of that period with me. I was in seventh and eighth grade, and there were times we didn't have money to buy even the simplest notebook for me. I also had to start taking responsibility for my family, waiting in line for rations of oil, milk, gas, everything.

After a couple of years, my mom inherited my dad's pension, and we went from not having anything to overcompensating for the "poor years." My mom tried to make it up to me by showering me with gifts. I became a spoiled, entitled brat. I still am.

I care about how I present myself. I care about making people understand they are important to me by not arriving sloppily dressed to my appointments. By being well dressed, you convey authority and ››

Predrag at Pozorište na Terazijama (Theatre on Terazije)
for the premiere of *Zona Zamfirova*, a reinterpretation
of the 1906 book by Serbian author Stevan Sremac.

self-care, you convey that you've made an effort to look nice for the person you're meeting. Especially in a group setting, people see you differently. I just celebrated the twentieth anniversary of my high school graduation. The women there looked nice. The men were a total disaster. I wore a pink suit—a no-no in the straight world—and checkered Givenchy sneakers, a white shirt, and a pink tie. When you look at our group photo, the only thing you see is me, standing out in my pink suit. It amuses me. When people notice you're well dressed, things are a little easier. When I go to the post office and I wear a tie, I

notice the difference. People are kinder. They make more effort.

I knew I was gay on my first day of school. They were seating us one boy, one girl at each desk. I wanted to sit with a boy I thought was very cute. Of course, that wasn't an option.

In our school library, I stumbled across an old book from the sixties. It said something like: "Homosexuals: mostly ballet dancers, waiters, etc." It was so vague. Elsewhere, I came across some porn magazines that occasionally had some gay content. In Serbia at the time, it was easy for teenagers to buy porn. Partly because I had no other way of learning, I started experimenting quite early with my friends. I was fourteen when I had sex for the first time. He was my classmate. We were together for a long time. Then, he got married to a woman, became severely depressed, got divorced, and moved to Palma de Majorca, where he now lives as an openly gay man. That's not an unusual story here.

People here are traumatized by their time in high school, but I wasn't. I hung out with the coolest kids in the school, the popular girls. No one bothered me. I had money. We were going out all the time. ››

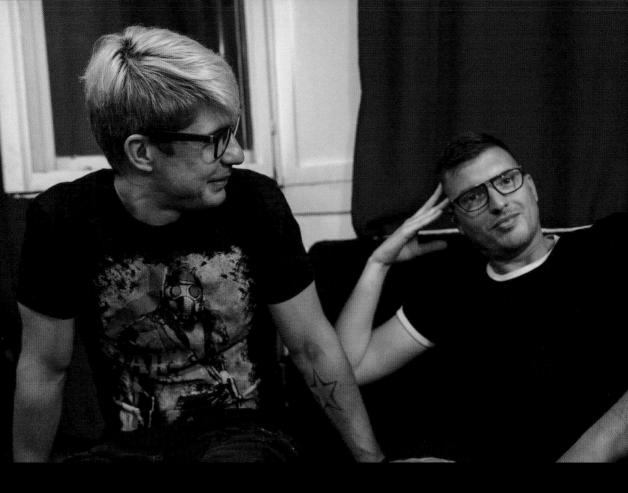

It was fantastic. Puberty hit me hard, and I was getting myself in trouble all the time. I'm glad I managed to make it safely through that period.

Milanče has a peculiar relationship with his family. They don't know he's gay, but they also don't know anything about him, period. I'm not sure if this is because he decided to keep them out of his life or if they chose not to be interested or involved. There's a little bit of that in my own life. My father died before I came out, but my mother knows everything. She's always known. But I don't talk to my mother about it. Even when I was still living with her and my boyfriend was visiting, we didn't talk about it, even though she knew everything. She's accepted many things about me, but her biggest worry is my safety. She's afraid that someone may physically attack me—or worse, kill me. She loves me and cares for me, but she just can't talk about these things.

I was born in Germany. People always ask me why I just don't move back. The fact is I don't really want to leave Serbia. I like it here. As big of a shithole as this place may seem, I'm happy to live here. At the end of the day, I am someone here. I have some kind of status. If I were to leave, I'd need

to start from zero, and I'm old. I'm turning forty next July. I can't be starting from scratch.

I'll continue to work on *Optimist*[1] and Merlinka,[2] but I'd also like to expand my work beyond LGBTQ issues. It's so hard because my brand is LGBTQ issues. I can keep telling people I'm a journalist, but for them, I'm the "gay activist," period. There's no turning that back.

I get sucked into the activist world all the time. I'm someone who can give a good overview of what's going on in Serbia at any given time. I can analyze what organizations are doing and comment if need be. I'm not a malicious person. When I speak about issues, I always want to make things better, even when I'm at my most severe and critical. I want to help. This is quite rare in Serbia. I also like to be criticized myself—not personal attacks but constructive criticism of the way I might be doing something. It makes me want to improve. People here take everything so personally, and that's a problem.

I believe that I have a legacy, a public image,

1 The only LGBTQ-themed monthly magazine in Serbia.
2 The only LGBTQ film festival in the Balkans.

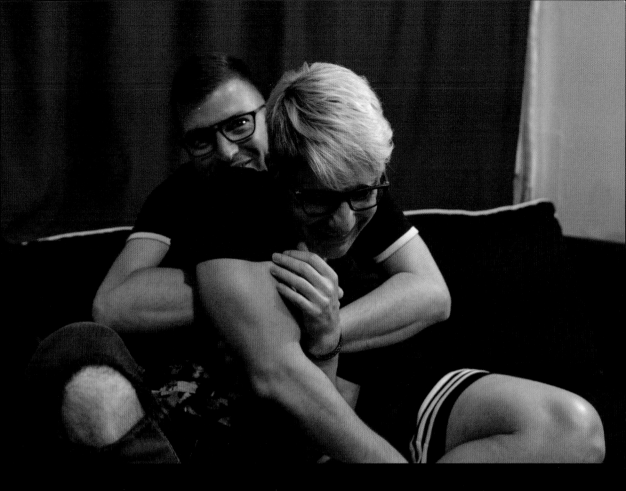

and I'm afraid of damaging or losing that legacy. My biggest fear is not being taken seriously, that people might say I was a clown or a fool. I can't afford to be a daydreamer. I can't see much change coming to Serbia anytime soon. We've had so many "democratic" changes here, but I can tell you that practically nothing has changed. The basic principles on which our country functions, politically, economically, are the same as they were twenty years ago. The only question is: are you part of, or outside, that system? Most people want to be a part of it. That's where security is. That's the reason why we have people we call "flippers," politicians who change parties every election. They don't belong to a certain political movement, because they don't believe in anything. They do what's convenient for them. I don't see any of this changing anytime soon. It's cultural. Maybe Serbians don't want change. We have to be realistic about the society we live in. We shouldn't have unreasonable expectations.

There's an epidemic of corruption here. What can we say to the younger generations: "Study, and it'll pay off"? I don't think so. I never say that to my niece, who is twenty. I tell her, "Yes, you need an

"You need to know how the system works. You're either in, or you're out, unless you're rich, but that is a very rare privilege."

education. You need good grades at school, but more importantly, it's who you know, not what you know that really matters. And above that, it's who knows you, or who knows of you? When I pick up the phone and say, 'This is Predrag Azdejković,' they already know who I am. Most of the work is done. That's the way it goes in Serbia. Nepotism above all. There's no other way to succeed. If you want to escape Serbia, you should go to school and study hard, but if you want to stay here, you better know some important people. You need to know how the system works. You're either in, or you're out, unless you're rich, but that is a very rare privilege." ›››

USTAV NE DOZVOLJAVA PREMIJERKI DA SE UDA!

Predrag protesting at the Pride parade with a sign that reads, "The Constitution doesn't allow the prime minister to get married." Prime Minister Ana Brnabić, who is openly lesbian, attended the parade.

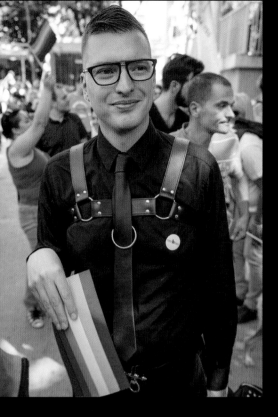

"Instead of working together,
we're fighting and tearing
each other apart."

In Serbia, there are many gay men who are wealthy and closeted. It's not in their interests to fund any activism here. They already have respect, contacts. They're never discriminated against. They have financial security and physical safety, so they don't need to change the system. They're rich because of it. It's their own privilege they're not willing to put into question. People don't even need to donate money. They could donate services, time. But here, in Serbia, everyone expects to be paid for any work they're doing.

There are also many gay people in Serbia who aren't professionally successful, and some of them use homophobia as an excuse for their failure. Serbia isn't the worst place in the world for gay people. Society here is not that homophobic. So, when faced with that, they lose their excuse and freak out. They try to sabotage the progress we're making. It's so self-destructive. It seems like they can't be happy about anything, even about the positive things that occasionally happen. Instead of working together, we're fighting and tearing each other apart.

In Serbia, no success goes unforgiven, especially if it's achieved by the underprivileged: Roma people, women, or LGBTQ people. We all know what's wrong in this country. We all talk about it all the time, but somehow we never seem to solve any of those problems. We've been telling the same story over and over again for years, but nothing ever changes.

The LGBTQ movement in Serbia doesn't have enough financial power to become relevant. If there were more money, we could help build a sense of community. There are things happening already, from public viewings of RuPaul's Drag Race at KC GRAD, to many other events, but it's not enough to make a significant change in the way people think. Young people are thirsty for change, but they don't feel like the world of activism speaks for them. We're slowly making changes. We're no longer seen as a genocidal nation, and we now have a lesbian prime minister. Serbians are power-fearing, government-fearing people. They're afraid of authority, and the authority at this moment is a lesbian. Respect for her will come from fear more than anything else, and the LGBTQ community will indirectly reap some of the benefits.

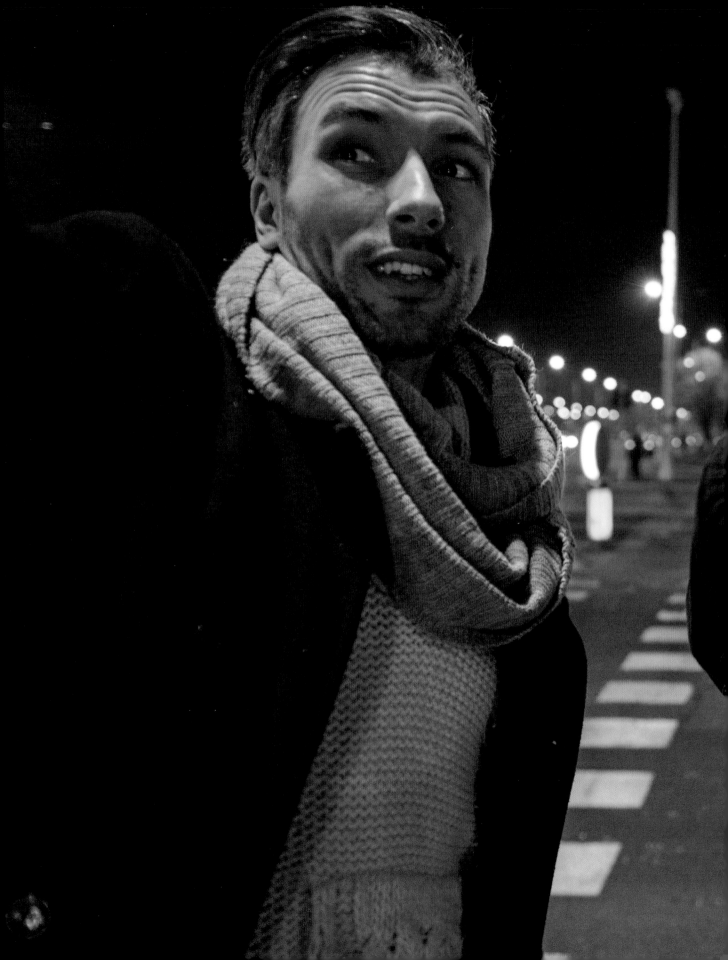

Srdjan Dimitrijević
Dalibor Vujović

"He loves me the way I am."

"In this society, you have to fit into a certain box, especially when it comes to gender."

Dalibor Vujović I identify as gay—so gay!

Srdjan Dimitrijević I identify as a proud gay man.

DV I don't feel like a man. I've always felt like I should act like a man, but I feel like I'm somewhere in the middle—maybe androgynous. Sometimes, I catch myself carrying myself like a straight man because a lot of the time I have to act the way society expects me to. But generally, yes, I see myself as a gay man. I mean, all my life, in school, when there was a clear division between boys and girls, I never felt I belonged to the boys' group. I didn't feel like I belonged to the girls' group either.

SD I feel the same way. I never felt like I belonged with the boys or the girls. I was just me.

DV In this society, you have to fit into a certain box, especially when it comes to gender. For example, at my last job, I remember saying something about a project, and a colleague told me, "You're always whining like some woman. You're really pissing me off," and I was like, "Oh, that's where you're coming from? If you think that a man acting like a woman is something bad, I guess we have a problem here." Almost every day at work there was something similar—one of the many reasons why I decided to quit my career in IT and pursue my lifelong dream to be a hair stylist. Then, at the hair salon where I started working, they told me, "It's the first time we've had a man working here," and I was like, "Why is that important? What you've got here is a professional who's ready to make this thing work in the best possible way for all of us." It really upsets me, the gender binary, the gender norms that are imposed on people. I don't want anyone to tell me what I am and what I am not, or what I should and shouldn't be.

We do get unusual questions from curious people we know, friends of friends. They just don't have much exposure to queer people and find them exotic and fascinating. They're more ignorant than mean. They usually have questions about the "gay world" in general, not intimate questions about our relationship. In their minds, it's like, if you're gay, you have to be some kind of gay expert, you have to know everything about queer culture. It's funny. And stupid. My sister's boyfriend asked me if gay guys have sex all the time. I guess we don't have periods, so hypothetically, yes, we could. Needless to say, he was surprised when we told him that wasn't the case. Sometimes, we go without sex for a full month. You know, life happens, and sometimes sex feels like a big production, so we'd rather just cuddle, or watch a movie, or talk. But if we don't have sex for a long time, it does cause tension. Not because we haven't gotten each other off, but because we feel like we should be having sex and we're not. It almost feels like we're not fulfilling our obligations. But we talk about it. We sit across from each other and just face our issues. So, in the same way as my sister's boyfriend feels like gay men should be having sex all the time, I sometimes feel like we should.

We've always been monogamous. We've been together for over six years. We just celebrated our sixth anniversary in August. We got each other matching necklaces, like rings. For me, love means ››

Dalibor (left) and Srdjan (right)

**"There are so many moments when I feel love and connection.
When we snuggle, when we cry at the same scene in a movie,
even the smallest things, that's love."**

forgiveness, acceptance, but, honestly, I don't
really have a clue what it means. We're all looking
for it. We're all trying to understand what it is. This
frustration around defining love, it's just another box
we're trying to put each other, our real selves, in.
Even after six years of living together, I feel like we
should have moved from falling in love to loving each
other, but I still don't know what that means. One
thing I do know is that, more than anything, I love
falling asleep and waking up next to him. That's it for
now. I also do love to wake up by myself sometimes
as well. [laughs]

SD You can't love others if you don't love yourself.
On the other hand, love is work. It means acceptance,
sacrifice, understanding, learning new ways of thinking,
and creating new points of view. We're not brothers.
We didn't come from the same mother. We grew up
in different environments. We have different habits.
After six years, there are still occasions when we see
something we haven't seen before. It's important to
recognize this so we can talk about it and grow.

DV He's a love-aholic.

SD I am! There are so many moments when I feel
love and connection. When we snuggle, when we
cry at the same scene in a movie, even the smallest
things, that's love. I don't like to be bitter. I don't
like to remember bad things. I think arguments are
normal, but I move on easily. I like to think positively.
I'm not good at fighting. It's too stressful.

DV I do have a problem. I'm always thinking
everything has to be perfect, including our
relationship. So, in my head, I'm trying to be perfect,
and I try to make him perfect. I'm a control freak.
When we travel, I want everything to be perfect, and
I spend so much time planning the details, which
turns me into a miserable person and a difficult travel
companion. I try to loosen up as much as I can. It's
better for both of us.

SD Earlier, I said we're different individuals, but,
that said, from day one, we felt like we were super
compatible. Somehow our daily habits, the way we
inhabit the same space, the way we think about
things, our core values, they're pretty much the
same. At the beginning of our relationship, that was

very strange thing for both of us. We'd never met anyone who thought in such a similar way.

DV Well, it wasn't like that from the *very* beginning. I had to pursue him for a long time, do the proper courtship. He was my project. He was in a relationship with another guy, who my best friend had a total crush on. I was supposed to seduce Srdjan away from his boyfriend. I hated the whole idea of doing something like that. One night, my friend and I went out, and I saw this really nice-looking guy with a great smile. I was drawn to him immediately. Before that, I was too difficult for anyone to date. I wasn't really interested, and I didn't have time. I had a career to focus on. But I saw this guy, and I told my friend I was interested in him, and it turned out it was the guy I was supposed to distract from his boyfriend. It was Srdjan. We started writing to each other, and, little by little, we began to feel a connection. Srdjan and his boyfriend broke up shortly after that. We kept writing to each other every night, but he wanted to just be friends. After a few months of this, I told him that I wanted him as a

boyfriend, not as a friend. We stopped talking to each other, but after a few months, we saw each other at a club, and we finally admitted to one another that we wanted to be together. It was the beginning of—what still is—the best period of my life.

SD I had enormous problems accepting myself. That was hard. I struggled with it for a long time because of my family, because of the city I grew up in, Užice, in Montenegro, and the narrow-minded environment there. I don't see it necessarily as a kind of trauma. I don't think I can eloquently explain how I felt back then. The process of my coming to terms with who I am and accepting myself took a long time. It didn't happen overnight. I always knew I was different. I didn't necessarily know how to define it, but I had no doubts that I was different. I always hung out with girls. I loved dolls. I'd put a blanket on my head and pretend I had long hair. There were so many signs.

I became certain of my sexuality when I started high school. I had friends, I even dated girls, but I always felt alone. I never had sex with a woman. It was only when I came to Belgrade and started college ››

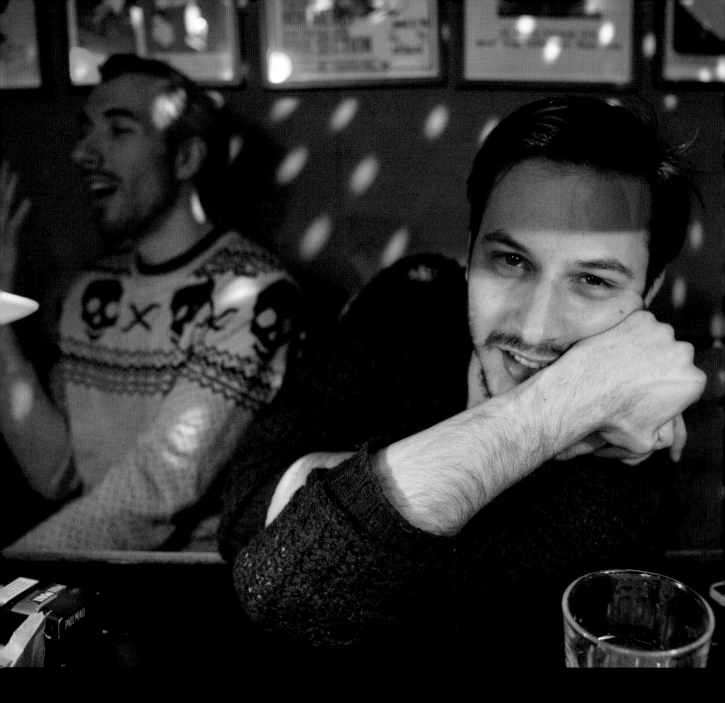

that I discovered people like myself, the gay scene in Belgrade. I started to overcompensate and do crazy things, experimenting with guys, which eventually got me in the same situation where I felt like I was alone again. It took me a long time to understand myself and to love myself. I wasn't concerned about what my parents would say, or what anyone else would say. I had a problem with myself. I started watching gay porn early on. It was the only way to get any kind of exposure to gay culture, and porn was easily available. I knew that what I was doing was

wrong. I felt a tremendous sense of guilt. I felt like I was going out of my mind, and I decided that I had to either accept myself or commit suicide.

I learned to accept myself in my first year of college. I decided that suicide was not an option and promised myself that I wouldn't make myself feel guilty anymore. Shortly after that, I met Dalibor. I never felt like anyone ever loved me the way he did —and does. It made me feel very special. Until then, nobody knew me, nobody saw me for who I was. I didn't let anyone in. He saw me.

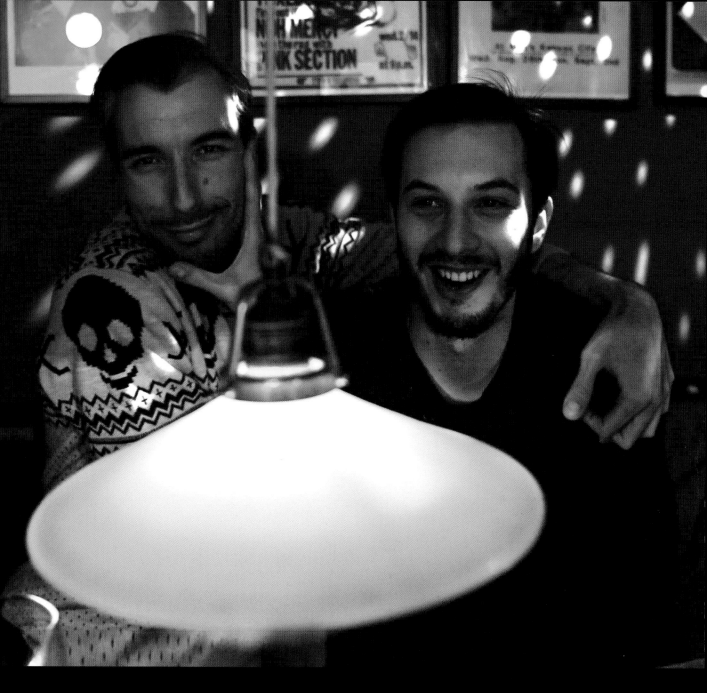

DV When I was growing up, I was always scared that I'd get beaten up. Even today, when I walk down the street and see a group of straight men, I get serious anxiety. I either cross the street or avoid eye contact. I just look down and pretend I don't see or hear them. This isn't totally irrational. I was bullied a lot in middle school. One time, a group of older kids waited for me after school. It was late in the afternoon, and it was almost dark outside. They were waiting for me in the park near the school. They attacked me. They hit me and kicked me with all they

had. It seemed like an eternity. Eventually, I managed to run away and get back home. Since then, I've never stopped having anxiety attacks. Even today, I always make sure I know who's behind me. The way I sit in public spaces, my back is always protected. Even though I know I'm an adult and I'm not offensive to anyone, I just can't stop this terrible feeling.

SD I've been bullied as well, but my reaction has been exactly the opposite. I walk through these groups of men. I have the right to be there, and I won't let anyone take it away from me. ››

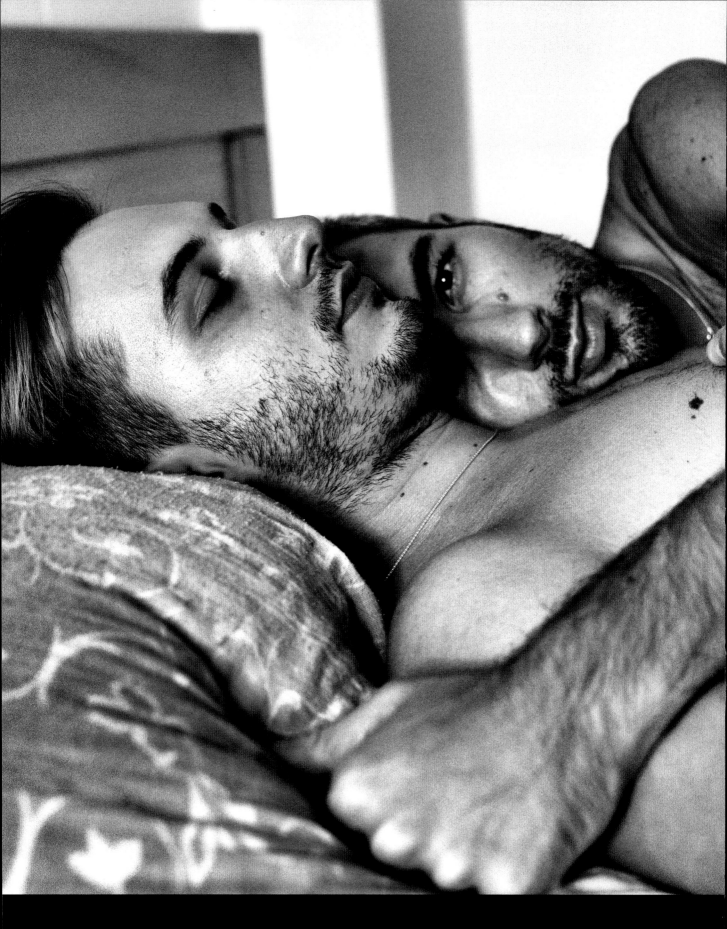

"When I think of the future, I want to be able to walk on the street and hold his hand without fear of being attacked, either verbally or physically."

DV People frequently call us "faggots" on the street, asking us sarcastically if we are going to a soccer match, which is something that macho straight men are supposed to do. In those moments, we both shut down and keep walking. Once home, we've built up so much stress that we can't stop talking about it, imagining how we should have reacted. But reacting can be dangerous. There are some seriously violent people here who can't wait to pick a fight.

When I entered this relationship, I had very clear life goals. I had a career ahead of me. I was ambitious. I needed to finish my education. I thought this would be a short crush. I'd have fun, and once it was over, I'd move on with my life. Needless to say, what happened was exactly the opposite. I was so taken by him, I fell in love, and this relationship became the most important thing, and Srdjan the most important person, in my life. Today, the only future I see is with him. I don't know if this sounds silly. Maybe it's cliché. But for me, it's not. I never thought I'd be in a relationship of this kind, so, for me, to feel that I have someone so special in my life and to want to spend it all with him, that's so special. I want to live together in a country house full of dogs. I have so many visions of the future. Most of them will come true. I work hard for what I want, and I don't stop until I've reached my goals. Sometimes I am a little obsessive about it all, but Srdjan is here to bring me down to earth. He is my reality check.

SD What I learned to do is support Dalibor. We support each other and try to never put down each other's ideas or needs.

I started working fairly early on because I was afraid that, if my parents found out I was gay, they would cut me off financially; I had to make sure I had an income and that I was independent. I didn't want to ask for money from them. For a while, I was »

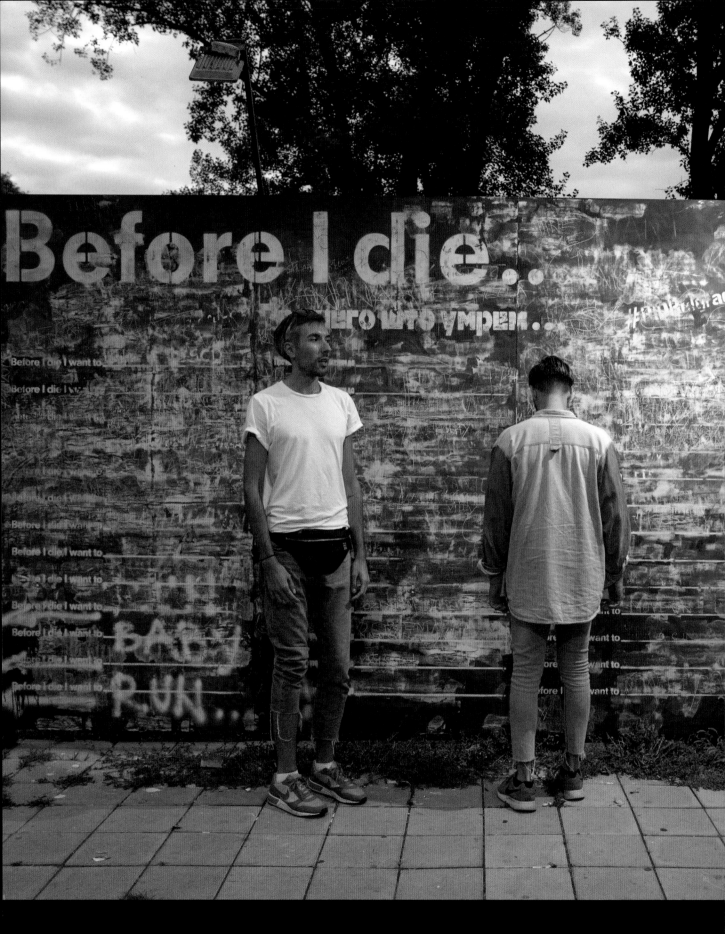

"Life is good. I haven't figured everything out yet,
but that's the fun part, the challenge of it all.
One way or another, the glass is always half full."

studying and working at the same time. I had to pay for everything. Toward the end of college, my job distracted me from studying. I got promoted, got bigger responsibilities, and life took over. Now, I really need to go back and get that degree.

DV I have a great relationship with my mom. With my dad, not so much. They're still married, but in my head, I treat them as individuals. I almost think of them as divorced. From early on, I never considered their marriage a perfect one. This is, of course, my problem. Their marriage is probably fine. I just have high standards. I always felt that my father was so independent. He never respected my mother the way she deserved to be respected. It's a typical Serbian marriage.

I started working after high school and was always obsessively focused on my achievements. Srdjan seems like he wants to go to work and come home and just hang out. I push him to do things outside his comfort zone, to do yoga, to go to shows, to go out with friends. He'd be happy cuddling on a couch and watching movies all night, but I want us to do a thousand things. There's so much happening in Belgrade, and I don't want to miss it all. This first month at my new job, I've been working literally ten to twelve hours every day. He asks me if it's exhausting, but this is life. If I want to create something in life and get financial security for us, I know I have to work very hard for it. I enjoy it!

SD Every time I see how quickly Dalibor reaches his goals, I feel more empowered to keep on going and to push even harder. I'm so proud of him. When I think of the future, I want to be able to walk on the street and hold his hand without fear of being attacked, either verbally or physically. I think about that all the time. I'm not the kind of person who has a clear vision of the future. I love Belgrade, but I'd like to live somewhere else as well. I can't imagine spending all my life in one place. I want to live somewhere where I can just be me, where I can simply be, where I can dress the way I want. It hurts me to see him anxious in the street or at a club. All I what for myself, for us, is that we can be safe, that we can live together in a small house with a garden—we love to cook, we're both vegetarians—and that we can travel from time to time. That's about it. No huge expectations, really. I see myself with him until the end.

DV I used to always be full of fear—fear that I wouldn't be professionally successful, that I wouldn't have a good boyfriend, and after we started dating, that he and I would get into a big fight and split up, that he would cheat on me. I had so many different fears. Today, I can tell you with confidence I don't have many left. I'm dedicated to him, to us. It makes me feel confident and good. Professionally, I'm starting something new, and it's amazing. Life is good. I haven't figured everything out yet, but that's the fun part, the challenge of it all. One way or another, the glass is always half full.

"I'm finally okay with just being me, and it's an amazing feeling."

Saša Masal

> **"I had to work hard to get here. There was an infinite amount of blood, sweat, and tears. But as Oscar Wilde said: 'Be yourself; everyone else is already taken.'"**

I feel like everything's slowly falling into the right place. I've started to see a pattern in everything that's happened to me, and I love where it's brought me. I'm in such a good place now. I feel like all the shit I've gone through is finally coming to an end. I feel that I'm starting a new period in my life, a new chapter. I'm ready for the new stuff, and I am so excited! I feel purged of all the drama, the tragedy, the heartbreak. It's all over now. Clean slate.

Did you see the video for Taylor Swift's "Look What You Made Me Do"? At the end, she says, "I'm sorry, the old Taylor can't come to the phone right now. Why? Oh, 'cause she's dead!" It is just like me—the old Saša is dead too! I'm embracing my natural looks, my own hair color; I'm applying minimal makeup, just a touch. I'm just being me. I'm finally okay with just being me, and it's an amazing feeling. It's my face, and it's my hair—fuck it! If you don't like it, piss off!

I've tried so hard—too hard, if you ask me—to project this ideal image of myself. But at the end of the day, I realized that until I learned how to love and accept the real me, I would never find happiness, and I would never be able to love anyone else. As simple and cliché as it may sound now, I had to learn to love myself just for who I am. Trust me, I had to work hard

to get here. There was an infinite amount of blood, sweat, and tears. But as Oscar Wilde said: "Be yourself; everyone else is already taken."

My mother passed away two years ago. After that, I had to be strong. I didn't have a choice. I couldn't fall apart. My whole world imploded, and I was on my own. Alone. Two weeks she got sick, and two weeks later she was gone, fourteen fucking days. She had this cold that she kind of neglected. It went on for some days, and all of a sudden, one day, she got really sick. She was diagnosed with severe pneumonia. The whole thing could've been avoided if she'd only gone to see a doctor on time. It all happened in a day. She went from being flu-ish to practically being in a coma. She stayed in a coma and was kept on a respirator for two weeks.

She did eventually wake up, and they even took her off the respirator. The infection in her lungs cleared up, and she was about to be released from intensive care. Her lungs were fine. Then, her kidneys failed. It was maybe from the medications she received while being in a coma. That's what got her —a kidney failure. It was a perfect storm. Bam, bam, bam, done, gone! ››

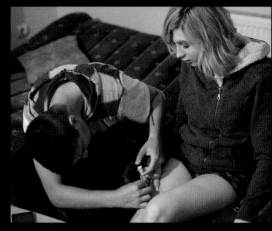

Aleksandar giving Saša a shot of estrogen.

I'd never gone through anything like that before. That moment when I saw her in the morgue, on that slab, my universe imploded. My entire existence, my entire being, just fell apart. My old world was gone, forever, and there was nothing I could do about it. But there was something I could do about my future: I had to make sure I would be all right.

Work kept me sane—I design video games, and I love it. I got hired two or three weeks before my mother died. I felt I owed so much to her, and that she wouldn't want me to quit. I had to fight for myself, and by doing that I felt I was keeping her alive somehow. For a while I was like a zombie, but slowly it got better. My mom was my strength. She was always there for me and gave me unconditional love and support. And after she died, even though she was physically gone, she was still there, inside me. She pushed me through it.

I had good friends who were there when I needed to talk about it, but mostly it was me by myself. When you go to sleep at night, there is nobody else around, and that's when it hits you the hardest. That's when the real fight begins.

The people at work totally understand me. They are supportive. They always were, from day one. I feel

so blessed to be working for them. Often, I hear these horror stories from trans people about the way they get treated at work, and I can't really relate to that at all—I've never had anything but respect from my superiors and colleagues at work. I'm truly fortunate in that. As they say: "Shit in life, lucky at work!" Plus, I'm an LGBT person, and it would give them a bad reputation to fire a minority. [winks]

I had to start from scratch after I lost my mother, but I'm finally emotionally self-sufficient. I've been going from relationship to relationship, continuously. I was so desperate not to feel alone. Then, in these recent months, I took a break from all that dating shit, and I had time to realize that it doesn't really matter. Whether you feel like you have someone there or not, we're all alone in a way. It made me realize that I don't really have to have a person next to me in order to feel fulfilled. That's a fake source of fulfillment; it's not real, it's unstable, temporary, and, above all, it depends on other people's will or desire to stick around. It never lasts. I wasn't ready for a relationship back then, and I'm not sure that I am even now. I mean, as Björk says, "I have emotional needs"—and sexual needs, but the moment you call it a relationship, it becomes complicated, it's an emotional trap. Also, sometimes I feel the more you want something, the harder it becomes to get it, and vice versa. Once you stop obsessing about it, it just happens.

What people don't realize is that, for a relationship to grow, there has to be an open and sincere dialog. You have to confront each other about issues, turn them into opportunities, and build on them, make the relationship mature and grow. Some people are afraid to be perceived as needy, or that it ➤

> "There are so many things I can't control, so I always like to hope for the best and brace for the worst."

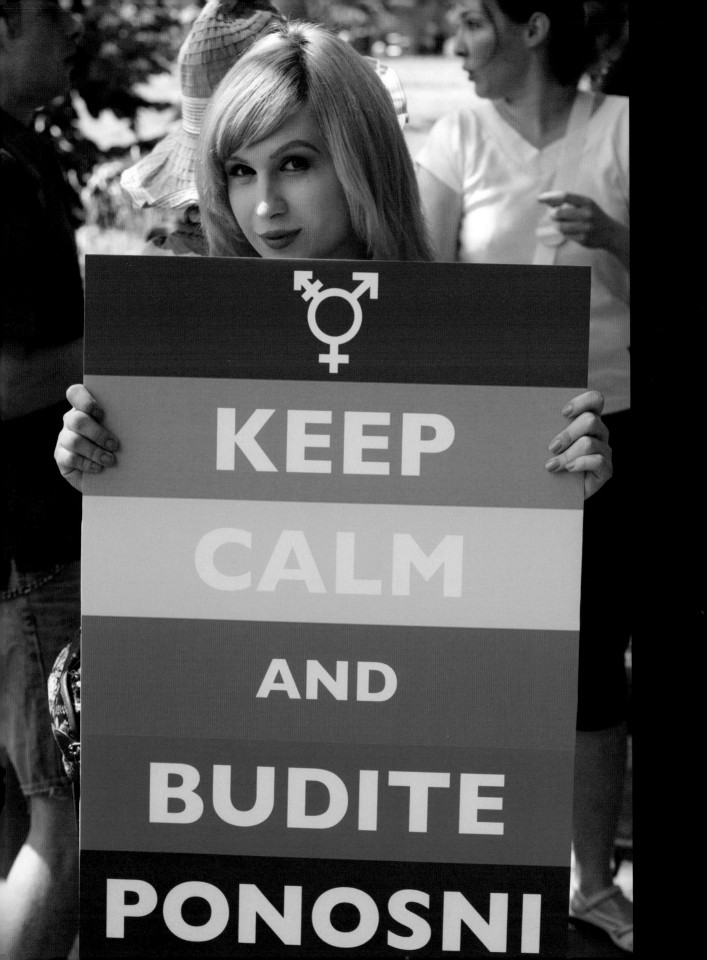

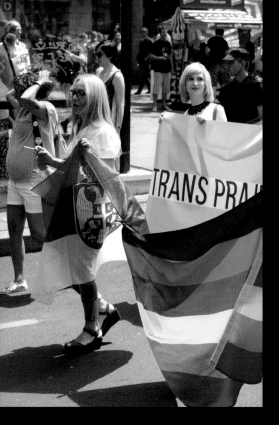

might become a problem if they ask for their needs to be met or fulfilled. I have needs, but I'm not needy. There's a difference.

I need to focus on this big project at work. It's taking so much of my time, and I really need to be super dedicated. I can't really focus on anything else, but after that's completed, I am planning to hammer through all the red tape and medical stuff. I'm definitely trying to save some money for the surgery, but you know how it is—I keep running into unpredictable expenses. For example, I just realized I need proper winter shoes, and I literally have none. My feet are always wet, and I'm afraid I am going to get sick if I don't buy proper winter shoes. But, in general, I'm okay. My brothers wanted me to renounce my third of the inheritance. They didn't feel like I deserved it somehow, or at least not as much as they did. One of them told me that he wished I'd died instead of our mother. Always such a nice person! Needless to say, I didn't give it up, and now I have some money on the side that I'm saving for the

surgery. I know that it's super expensive and that the recovery cost may be as high as, if not higher than, the surgery cost, so I'm well prepared. I like to plan ahead. There are so many things I can't control, so I always like to hope for the best and brace for the worst. I'm in a place where I don't want to try to control everything anymore. I'm ready to let go a little bit, and maybe catch a little bit of extra sleep.

I work hard, but not like before. I'm trying to find a healthy balance between my personal and my private life. It's tough, but I am really trying. I am twenty-five now. I feel like a new woman. I feel so happy right now, and I feel a sense of peace that I never felt before. I've been in conflict with so many people, about too many things, and I needed to forgive so much shit and be forgiven so many times. I've learned to let go and to pick my battles. I am a one-woman army—the army of me—and that's enough.

"I don't care any more what people say or think of me."

Marko Savić
Aleksandra Arsić

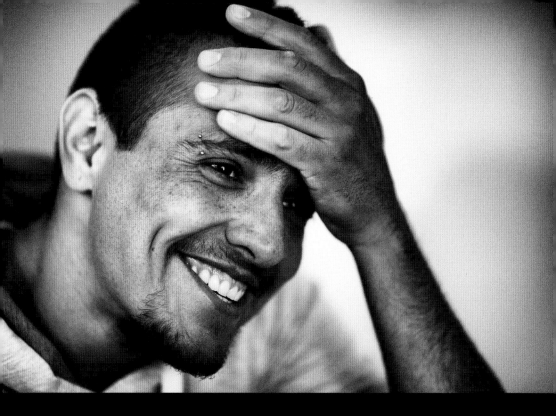

Marko Savić I see myself as a man. I am a trans man. I'm finally near the end of the transitioning process. I have been waiting for this for a long time. I'm thirty-five years old, and I postponed this thing so many times, but now I'm finally here. The surgery should be at the beginning of April. I'm so excited about it, but I'm also scared. It's expensive, and I can't really afford it. I still don't have the money to cover all the expenses. I'll have to find some way to pay for it.

I know the cost of the surgery itself is around four thousand euros. It depends on how much time you spend in the hospital. I'd have to pay one-third of that amount, around thirteen hundred euros, for the sterilization and mastectomy, but not for total penile reconstruction, testicles, etc. That comes at an extra cost, and I'll have to do it later. I really don't have the means to do it now.

The rest of the cost—for recovery, etc.—that's still a mystery. I can't think that far ahead. I'll cross that bridge when I get there. See, I'm not working now, and we're barely making it to the end of the month. We're barely managing to pay the rent, and here have been times when we couldn't even afford to buy food. I've had to beg my brother for help. I do

work occasionally, when things come up, but after the surgery I'll be out of work for almost three months, and that'll be difficult. But I'll be able to get a new ID and birth certificate. It'll probably take me a few weeks to do that, and once I get it, I can find a job.

We live on my girlfriend Aleksandra's salary and on help from my grandmother. Altogether, that's around four hundred U.S. dollars a month. But every month is a struggle. People keep telling me we should do an event to raise the money—like they did for Helena [Vuković] and her surgery. But I don't know. She's famous, a public personality. She has contacts. People care about her. People want to meet her, to be associated with her. I am no one. No one cares about me. My brother, my parents don't care about me. If my own family doesn't care, why would other people give me any money for my surgery? It just doesn't work that way here.

I've never expected anything from anyone. We did receive some help from close friends, but we've never depended entirely on anyone. Now, we're in a difficult situation. Some of it's because it's hard for me to find a good job. It's really hard. Imagine me, the way you see me now, applying for a job and

showing up. My name is different on my ID. It says "female" on my ID. Do I look like a female to you? Every time, people think I'm using someone else's ID, or that I'm pulling some kind of a joke. People don't take me seriously. It's devastating. I don't care what kind of a job it is—I'd do anything. But the way people are here, they don't take the time to get to know you; they'd rather judge you by the fucking gender marker on your ID.

One month later

MS I was recovering from the surgery. I wasn't okay. I was on a catheter for five weeks. Five weeks! The surgeon who operated on me refused to see me straight away, so I had to go to a private practitioner. I didn't know what was happening to me, but I knew that something was wrong.

Aleksandra Arsić One night, I got home after work, and Marko's face was red. I touched his forehead, and he was hot. He said he wasn't, but the following day, he was hot again. He refused to talk about it. He was in denial. He didn't want things to not be okay after the surgery. On the fifth day, I got really angry and forced him to take his temperature. It was 39 degrees Celsius (102 degrees Fahrenheit).

MS I was fighting a fever for two weeks, but I didn't want to tell Aleksandra, because I didn't want her to worry. It took my doctor ten days to see me, and he told me that my fever wasn't surgery related. He said I only had a common cold and should take Vitamin C, or that maybe I had appendicitis. I've had my appendix removed, so it was clearly not appendicitis. I felt like I was a joke to them. They didn't care. But I couldn't get out of bed. My whole body was in pain. I didn't know what to expect after the surgery. They didn't tell me even the most basic things. I don't know, maybe I wasn't listening. When you talk to doctors, it seems like you're going to get the surgery done and recover quickly. Instead, the recovery is long and frightening, partly due to lack of information and partly due to delays from the doctors. They make people wait so long that they're forced to go to private clinics, which cost a lot. I couldn't afford it, so I had to wait. I tried to go to another private clinic that was cheaper, but they refused to see me

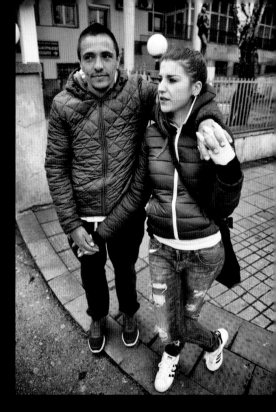

because the doctor said he had no experience with trans people and that he didn't feel comfortable examining and diagnosing me. He said I had to go to a specialist, so I had to wait.

AA After ten days of waiting, when one of the doctors finally saw us, she was visibly uncomfortable. She didn't recognize Marko, he was in such bad condition. She asked him, "Marko, is that you? Can you walk? I didn't realize things were this bad." Marko told her, "But I've been calling and writing every day about the pain and the high fever. What was I supposed to do to convince you? You told me the main surgeon was in Germany, that he would only be back in three weeks, that you had a conference, what was I supposed to do?"

MS I was really angry. They didn't treat me well. I had an infection in my stomach and was developing a lot of fluids that had to be removed. She did it quickly, but under wraps.

AA She was supposed to report the procedure and do it in an operating theater.

MS Instead, she decided to extract the fluids from my stomach there and then.

AA We went to a small room. She brought out a bag with sterile supplies in it and made me put it in

Marko and Aleksandra one day after his gender-affirming procedure.

my bag and told me to make sure no one saw the bag. I told her, "If someone sees me, they'll think I'm stealing things from the hospital. I don't even know what's inside this bag!" She told me to go inside and close the door and told Marko to keep quiet even if he felt pain. She didn't want someone to find out what she was doing.

MS She gave me a local anesthetic, stuck a needle in my stomach, and extracted a mix of blood and fluids. She only wanted to help me, and I'm grateful to her for doing it, because she saved me. I was feeling really sick, and she helped me. I just wish it didn't have to be that way. I wish they'd listened to me days earlier. I was recovering from surgery that they'd performed. They had the responsibility of following up during my recovery. It was the main doctor. I mean, he's a good guy, but he's just so busy. He may have become a little greedy. He had different priorities. His interests were his private practice and his teaching career. The others had no choice but to wait for his instructions. Their hands were tied.

I'm getting better now. I feel things are stabilizing. Even down there, I'm gaining some sensitivity. I'm not happy with my nipples, but at this point it is what it is. Aleksandra and I are okay. We hit a rough patch after my surgery and her father's death, but we're finally coming around. I started working with a friend, Niki. I work on construction sites with her. She remodels apartments, and I help her do the paint job, remove debris, anything she asks me to do. It's tiring, but it makes me happy. It's the first money I'm making as a man, and it feels ››

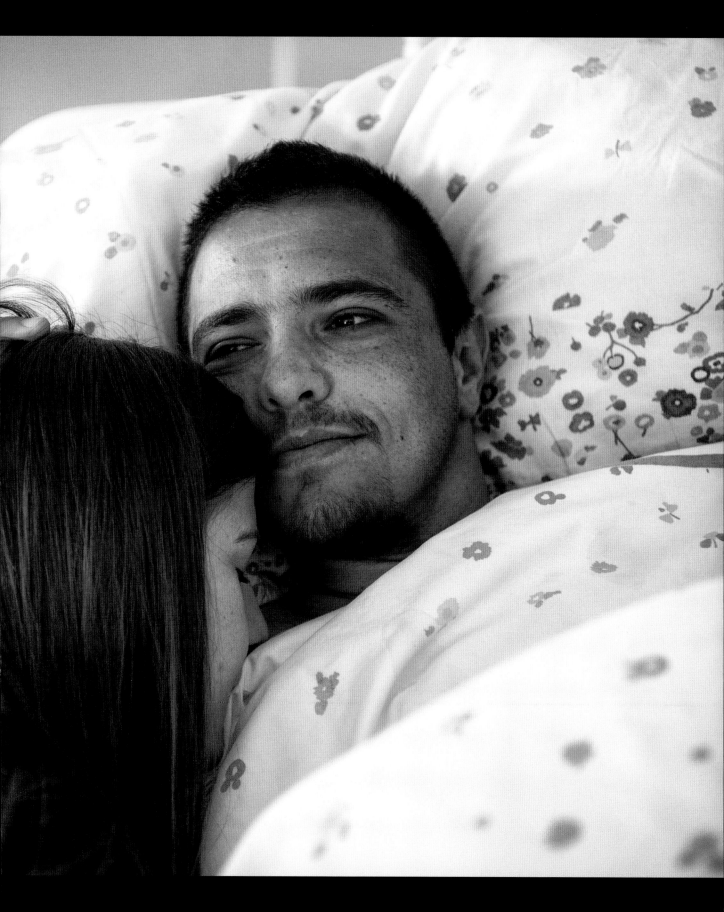

This is my time for happiness, and I won't let anyone take that away from me."

good. Sometimes, working on a construction site can be difficult from a practical point of view. I have difficulty urinating in public. I didn't really know it would be so complicated. I can't really use urinals because my urine stream is not strong enough. I should use a special kind of prosthetic funnel that looks like a penis, which you can just carry in your underwear, but they don't sell them here.

But I'm so happy to be able to go outside without a binder, without feeling self-conscious. This summer will be too early—I can't go to the beach because of the scars on my chest—but I can't wait till next year to finally, after almost twenty years, take my shirt off at the beach. I'm happy. Aleksandra and I have found a way to make some money and take some time off. We need a vacation. We deserve it. I am looking for a ring. I'm planning to propose to Aleksandra. It's a secret, don't tell her.

I still need to receive my ID. Without that, I won't

be able to do anything. I won't be able to get a new driver's license or anything else really. It all depends on that piece of paper. It won't get here until I receive an updated birth certificate and a certificate of citizenship. I hope it'll be done by the end of August. Just think: my surgery was the first week of April, and it's August now. Four months, and I still don't have the most basic identification documents, I still can't apply for a job or gym membership, I still can't travel. The level of disorganization in this country's bureaucracy is embarrassing. Every time I go to one of those offices, I get so irritated. There's so much carelessness; I don't get it.

My whole life has been a constant battle. I started feeling and acting differently when I was six. My parents never accepted me. My grandfather was the only person who gave me comfort and support. He would paint my bike in a color I thought was more masculine. He would buy me boys' clothing.

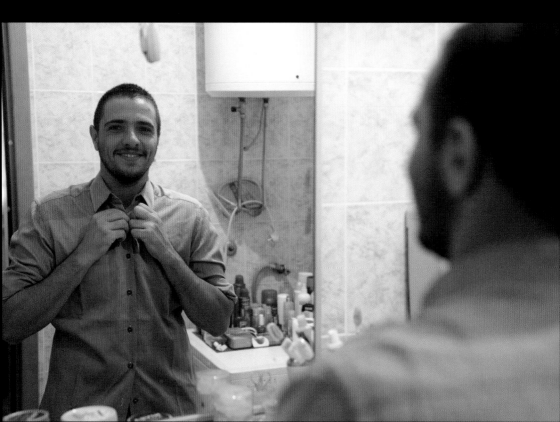

My parents were always against me. They still are. Growing up like that was hard. My brother always told me that my grandmother, who raised me, would hang herself if I did the surgery. It was pitiful. I postponed and postponed and postponed. I wanted to protect them, to please them. I wanted them to like me, to love me, so I put myself to the side. I disrespected myself. And for what? To be surrounded by people who don't even care about me? Well, enough is enough. They may as well be dead. I've moved on. Clean slate.

Now, I can finally walk on the streets. I can love myself and be me without any fear or any feeling of inadequacy. I don't care anymore what people say or think of me. This is my time for happiness, and I won't let anyone take that away from me.

One month later

MS I am a happy person now, the happiest person in the world. But I'm thirty-five years old, and it's painful for me to know I spent my first thirty-five years the way I did. Since I hit puberty, I've lived in a constant state of stress, and I drove my body to the edge of what it could take. My health deteriorated a lot. I was so depressed. My lifestyle was unhealthy. I had no will to live well. It's hard to live in the wrong body and for people to not see you the way you want to be seen. I love Aleksandra so much, but I need her to stick with me. I need her to be with me and support me without drama and negativity. I can sacrifice everything and leave tomorrow with just a backpack to try for a new, better life, but I'm not sure if she's ready to do that.

I thought the surgery would fix everything. I thought people would become more tolerant, that I would be happier. I didn't know about all the things I had to do after the surgery. I was naive and ignorant. I also hadn't been told clearly what to expect. Maybe I deliberately avoided asking certain questions because I was too afraid to know everything about the recovery. I'm not angry about it—well, maybe a little bit—but I'm disappointed that no one ever told me how expensive recovery would be. There were so many unexpected expenses. Any money I had was

stay here. We have to leave. There's someone I know who goes to work seasonally in Germany and Italy to pick grapes or apples. It's hard work, so I don't know if Aleksandra could do it, but I could help her, and I can work harder.

I'm not afraid to leave. Until a couple of years ago, my family was holding me back. They used my nephews to make me feel guilty. They said they wouldn't accept me and that I wouldn't see them again. Now, after the surgery, I realize they don't care—like, really don't care. No one from my family called me before the surgery to ask me how I was doing or if I needed anything. They knew I was going into a potentially life-threatening situation. There was deafening silence from them. In the hospital, after a couple of days, one of the nurses asked me, "You only have friends coming to visit you. Don't you have any family?" My brother called me the day after I left the hospital. I was in such physical pain. It was just under a week since the surgery, and my whole body was aching. I had a catheter, needles in my arm. I hoped he was calling me to ask me how I was, so I answered the call. Instead of wishing me a good recovery, he started teasing me, asking me how

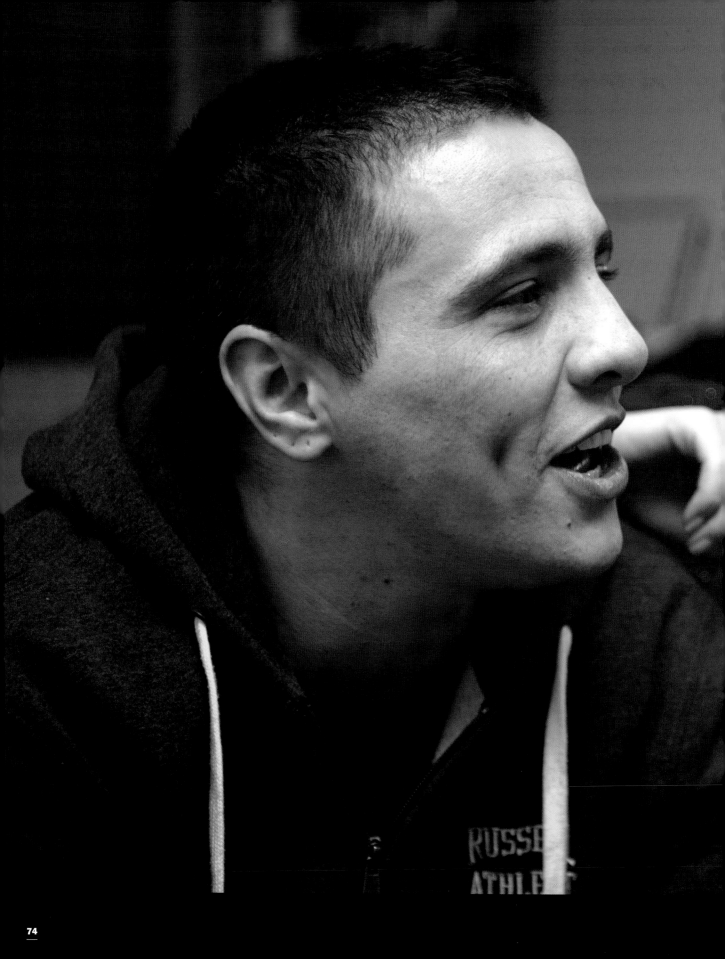

> "It's hard to live in the wrong body and for people to not see you the way you want to be seen."

planning to have children now. Can you imagine?

I was eighteen when I lost trust in my brother. For a long time, I kept giving him the benefit of the doubt, especially after his kids were born. He is a violent person—he always was. He treats his wife terribly. He beats her up. I hate violence, can't stand it. I can't forgive it. We used to fight because of his behavior toward his wife.

Once, as a gift to my mother, who was pregnant with twins, my father beat her up so severely she lost one of her babies. The doctor said that the other fetus was still alive, but he recommended an abortion. My mother refused. I was born forty days early. I found out about all this when I was twenty.

I feel lucky that I haven't gone crazy by now. I have no formal education. I have no property or savings. I have no family that wants to have me in their lives; it's one big nothing. Except for Aleksandra. She is my biggest love, a shining light. She knows how I love, with my entire being, but she knows that I am a simple man, an honest person.

After the surgery, I spent a lot of time alone. It was rough. Aleksandra had to work. So much time spent by myself, confined to a bed, in pain. Too much time to think about things. I thought I was going to go out of my mind. I'm lucky Aleksandra is such an amazing person.

If I could choose, I'd be anywhere but here. I would leave Belgrade, maybe even Serbia. The current situation in Serbia is not good. There's a lot of bad energy around. People are difficult and pessimistic. I can't function normally here. I still don't have my ID. It's taking so much time to get the basic things done after the surgery. I thought it would take less time. It's been five months since the surgery, and I still don't have an ID or a work permit. How am I supposed to live like this? »

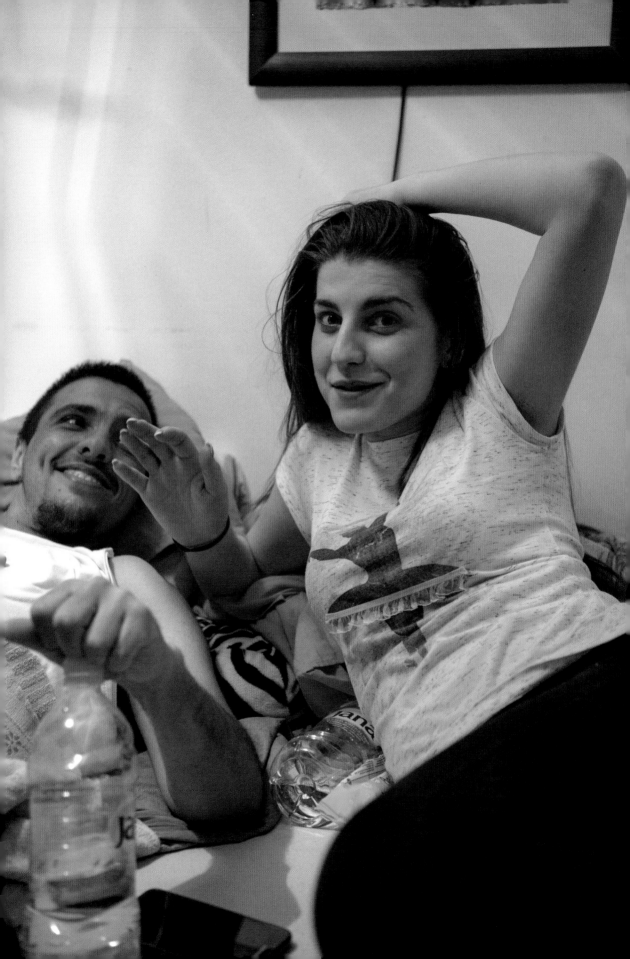

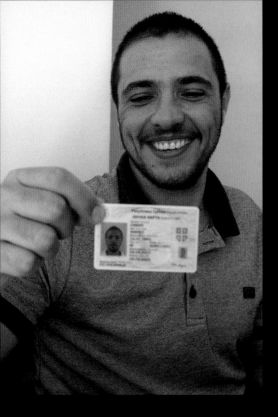

I can't even go to the post office. I've been ridiculed there more than once. Every time stuff like this happens, it opens so many old wounds. It's hard to convey this feeling of helplessness and hopelessness. The same thing happens at the hospital. Do you know how many times I've been in the waiting room and they come out calling my birth name? There have been times I pretended I wasn't there because I didn't want to go through the public humiliation. The nurses should know better. They do know better. On my file, there's a note that says I'm transitioning and that they should use my chosen name, not my given name. Sometimes, I have the feeling that they do it on purpose because they disapprove. As if I have a choice in this. Being trans is not a matter of choice. I didn't choose to be like this.

I don't want to be negative about it all. I want to take my own life into my own hands and make it better. I just need to have access to paid employment so I can live like a human being. Once I get my new birth certificate and citizenship, and after I get my new ID and work permit, it'll be different, I know. Things will change for the better.

I love when Aleksandra cuddles me, when she physically expresses her emotions and feelings. I

enjoy that more than anything. She's funny, and she likes to joke around. She's tender. I love that. I wish we had more time together. She works hard. I work when I can, and there never seems to be enough time for us to be together. I love to walk in the woods. It recharges my batteries. It's meditative, and I often do it by myself, but I miss her. For me, Aleksandra is love; she is all I want. She gives me happiness. Her smile means everything to me. I want her to be happy. I'd like to have a beautiful life together. I need to figure out how.

I'd like to have children. That's my dream. I want to have kids with Aleksandra, either through artificial insemination or through adoption. I'd like us to become parents in the next four or five years. I want to make at least one child happy, to give to that child everything I never had. I'd like to move away from the city, away from the traffic jams, the pollution, the negative energy. I would like to move to the country-side, to grow our own food, have an orchard, and live surrounded by animals, maybe some goats. Aleksandra would be okay with goats. Then we'd be happy.

"I needed to be able to live my life the way I felt I deserved."

Stefan Radojković

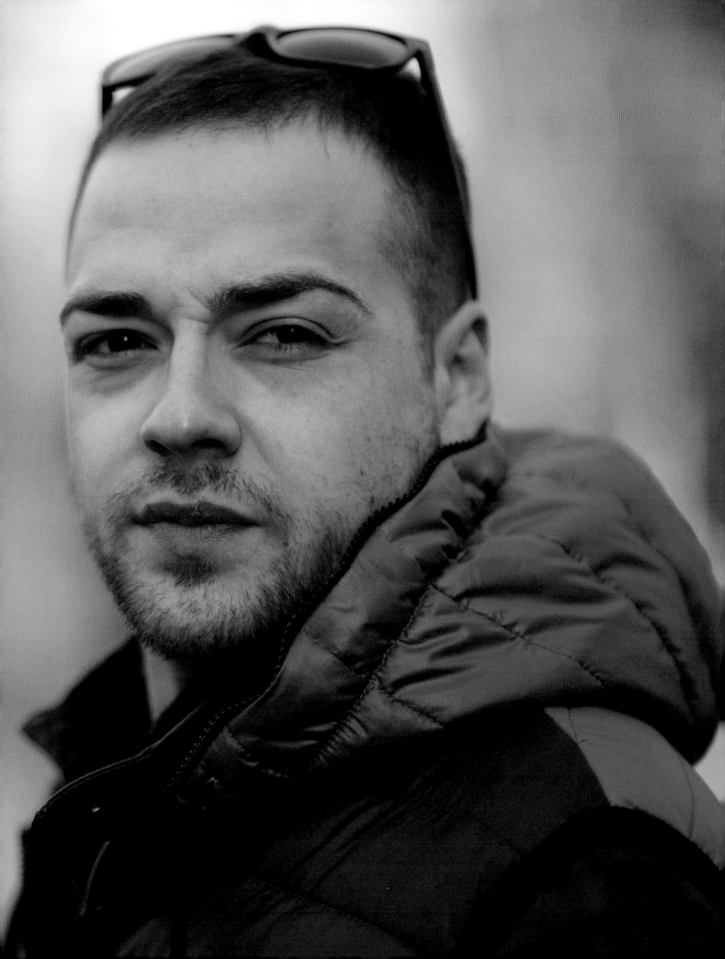

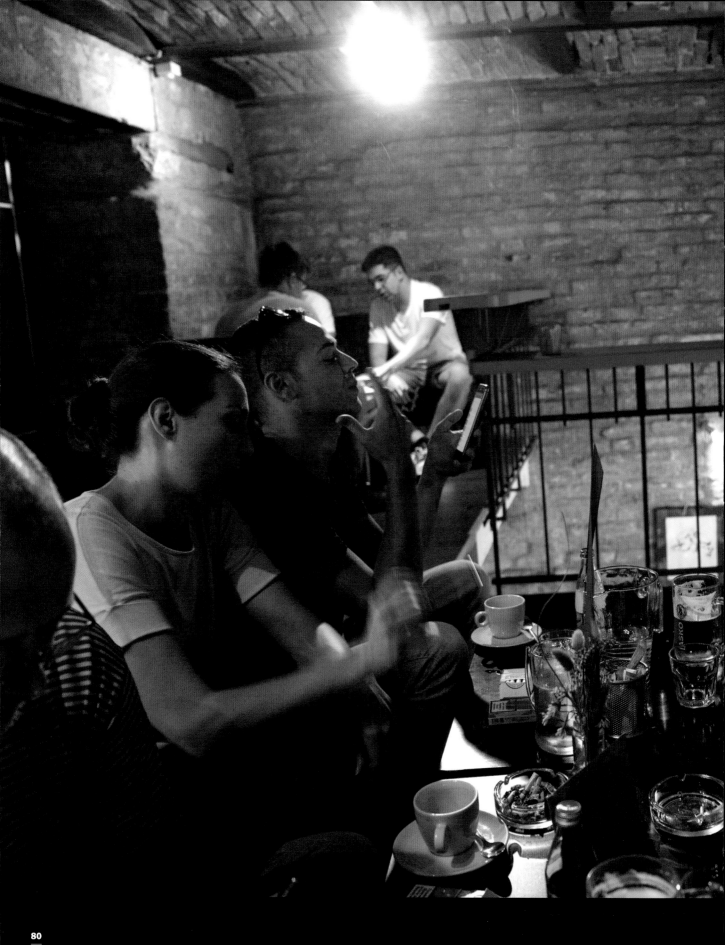

"There are a lot of people who are hoping I don't succeed. I'll prove them wrong."

I don't even know where to start. I'm complicated.

I realized I was different when I was sixteen. I figured there was something wrong with me, something not right. I was attracted to boys. I couldn't figure it out completely, and I was so afraid that my parents would find out about it.

My father was your typical Balkan man. Anything queer was taboo in our house—an absolute taboo. He would sometimes talk about how he couldn't understand what two men could do together, how they could sleep together. He would go on and on about how he thought it was wrong and how two men can't have a family together. My mom, on the other hand, never said anything about it.

That was a period of my life where everything I did was wrong in my father's eyes. He wanted me to play soccer. I decided to play volleyball. He considered volleyball a girlie sport. He wanted me to help him butcher pigs. I decided to help my mother make pastries. I started learning how to dance. For my father, that was unacceptable. From early on I had an ambiguous attitude about both my sexuality and ››

my gender. In school plays, I often played women's roles. He noticed. A pattern started to emerge in my behavior. I started wearing my mom's clothing and high-heel shoes and imitating Jelena Karleuša [a famous Serbian pop singer]. He sometimes pretended he was entertained by it, but in reality, he was not amused. My mom, on the other hand, figured it out. She was intuitive. She knew me better than anyone else. But she kept quiet.

At one point, when I was sixteen, I had a bad spinal injury and had to spend three months in the hospital, confined to a bed. I spent another two months in a wheelchair, plus three months on crutches. It was horrible. My entire year went by like that. They were not sure if I'd ever be able to walk again, and my father dropped the whole macho conversation. I guess my health was more important. He stopped saying in front of me things like, "Faggots aren't normal."

I'd had a huge crush on the tennis player Novak Djoković, but while in the hospital I fell in love for the first time. He was the doctor who was taking care of me. We slowly fell in love. My mom noticed »

immediately that there was something going on between us. She was more perceptive than I gave her credit for. I still believe this clandestine relationship motivated me to get out of bed and start walking again. I regained all the energy I needed to get back on my feet, and it really helped me deal with my depression.

After leaving the hospital, I started a different life. I never had to come out to my mother. She accepted me, and tolerated me, as difficult as it might have been for her. She accepted my

relationship with the doctor, which continued after I left the hospital. I think she understood how important that relationship was for me, and I think she was almost grateful to him for helping me deal with my injury in so many different ways. As dedicated as she was to my recovery, she couldn't give me what I needed. He could, and he did. She started covering for me when I'd secretly go to meet the doctor, and my father never asked me anything. He stopped with all the homophobic comments. I have a feeling that he knew all along. ≫

"I was twenty-one when Štefica become part of me. I'd like to be buried dressed as Štefica, but I'd like my epitaph to carry both names: Stefan and Štefica. I feel that the woman inside me is strong. I feel her all the time. I'm both of them all the time."

Shortly after that, my mother fell ill. She was diagnosed with cancer. I wish I could convey how I felt, how painful it was, that pressure in my chest—like I was about to explode—all the time. I started taking care of her. I dropped out of school. My father couldn't bear my mom's illness. He became depressed. He started drinking, a lot. He would drink a bottle—often two—of rakija almost every day. Our world started to implode. Four months after my mom was diagnosed, my father's body couldn't take it, and he had his first heart attack. He was bedridden.

He was in his late fortes. I'd just turned eighteen. I remember my eighteenth birthday as one of the most beautiful days of my life. Both my father and my mom made so much effort to make me feel special and important, and for one day I felt like I mattered.

My dad's pension was not enough for us to live on, and very quickly our living conditions became unbearable. I started working. I was taking care of both my mom and my dad. My mom was bedridden, and I had to do everything for her—feed her, bathe her, and change her diapers. My mom was confined

to bed for almost a whole year. I lost her around my twentieth birthday. It's a wound that will never heal. In her, I had everything. By losing her, I lost it all.

After my mom died, my father didn't stop drinking, even after his second heart attack. He loved my mother too much, and he couldn't handle losing her. He threw his life away. He passed away six months after my mom's death. On his deathbed, he told me that he knew everything about me, and he also told me that I had another sibling, a half-brother, a child he'd had with another woman before »

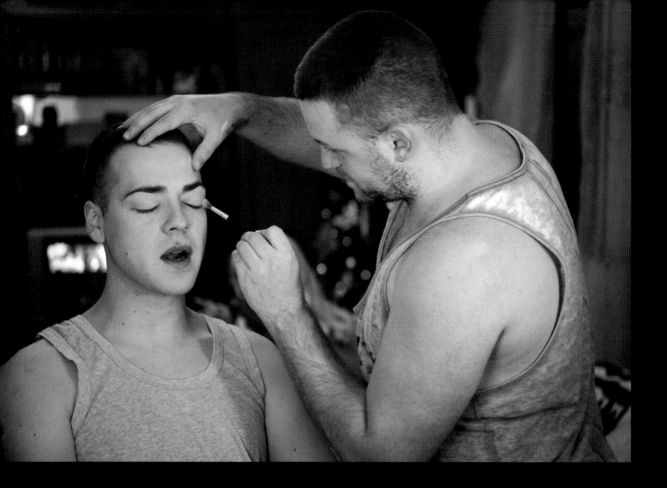

he married my mother and had kept secret all these years. It was so surreal to listen to him say those things, knowing that he was dying, knowing that I was about to become an orphan. I guess my father was trying to give me some reassurance that I wasn't alone, that somewhere out there, there was a person who shared my blood. He died shortly after that.

I decided to move to Belgrade. I broke up with my boyfriend, the doctor, after almost four years together. He didn't want to move to Belgrade, and I couldn't continue to live my life like that, in a secret relationship, hiding from everyone, hiding all the time. I needed freedom; I needed to live my life the way I felt I deserved, not in Ćuprija, but more openly and more freely.

One night, after a big fight with him, I packed my bags, called a taxi, and went to Belgrade. I remember it like it was yesterday. I didn't tell anyone I was leaving. My aunt tried to reach me for days. She was concerned, and after five days I finally answered her calls. I told her that I'd come home, but only to tell her in person why I was leaving. I returned home and came out to her, and she slapped me and yelled at me that it wasn't normal, that instead of finding

a girl and having a baby I wanted someone to fuck me in the ass. She said I was selfish for wanting our bloodline to end with me. She said the worst possible things—my closest relative. It was the moment I realized that I wouldn't have any support from her, that I was on my own. We didn't speak for the next two and a half years.

After two and a half years, I decided to contact her through a reality TV show. That was when I started wearing women's clothes in public. I was twenty-one. I was with a trans girl, Rajka, who helped me. She was my guide, and I started doing it more often, and at some point, Štefica was born. I enjoyed myself both as Štefica and as a guy, as Stefan. That's when I started having serious doubts about my gender identity. I didn't really know much about gender identity until then, and it took me a while to learn more and figure things out. Eventually, I decided to show up at that TV show as Štefica. My aunt was understanding and accepting, and I was in heaven. Things started going in a more positive direction after that. I realized I still had a family.

I do have someone here, in Belgrade, whom I consider to be like my mother. Vesna [Zorić] is one ››

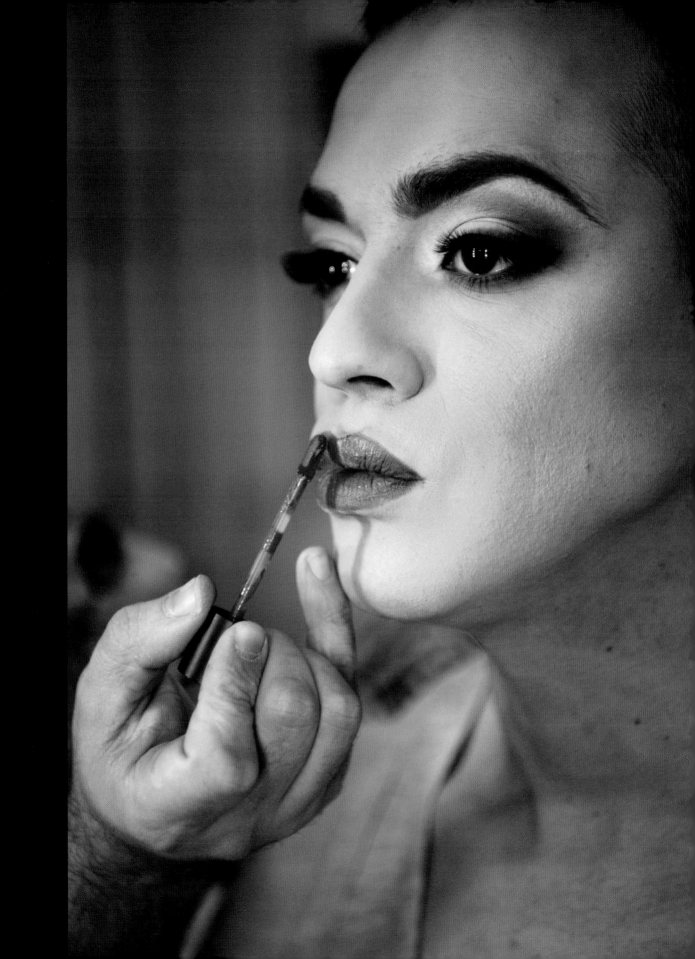

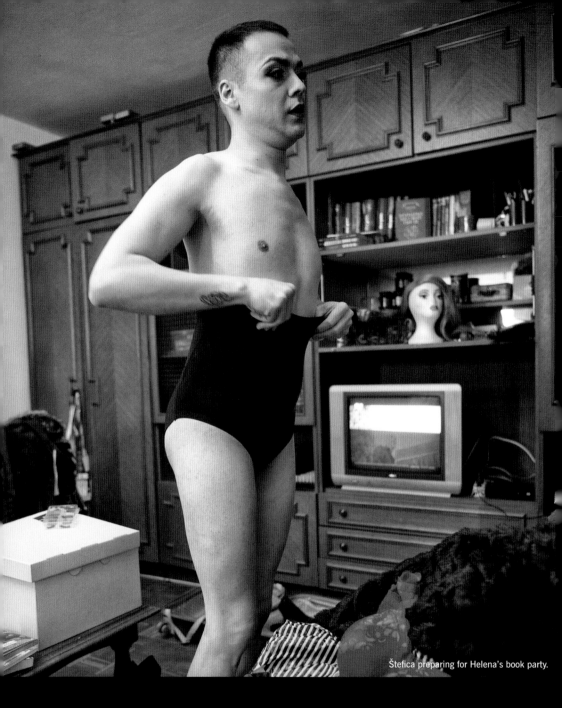

Štefica preparing for Helena's book party.

of the first people I met after moving to Belgrade. I remember I was in a cafe and saw her from behind. She was wearing a plaid shirt, and I thought she was a handsome guy. When I got closer, I realized she was a woman, and we both laughed about it. Vesna became my best friend, my family. She protected me from so many things so many times, but above all she tried to protect me from myself. She wasn't always successful, but at least she tried hard. She took me off the street and stopped me from going in a bad direction. I'll always be grateful to her for helping me

survive. I don't think I'll ever have the courage to kill myself, but I thought about it more times than I can count. My life didn't make any sense to me. I was a person without a family, alone, a "faggot" in Serbia, a "tranny." I felt my life was a waste, but Vesna helped me find purpose and a desire to keep on living. She brought back to my life the emotions, the love, that I'd forgotten existed after my mother died. That's when I fell in love with Filip. Sometimes, in hindsight, I regret that it happened. When we broke up I realized that he'd been with me only because

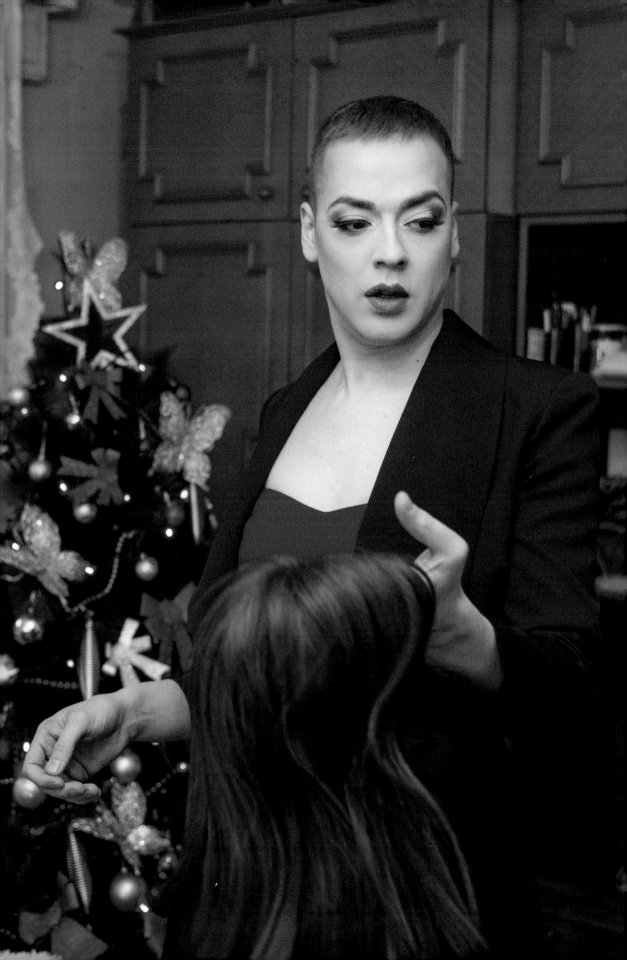

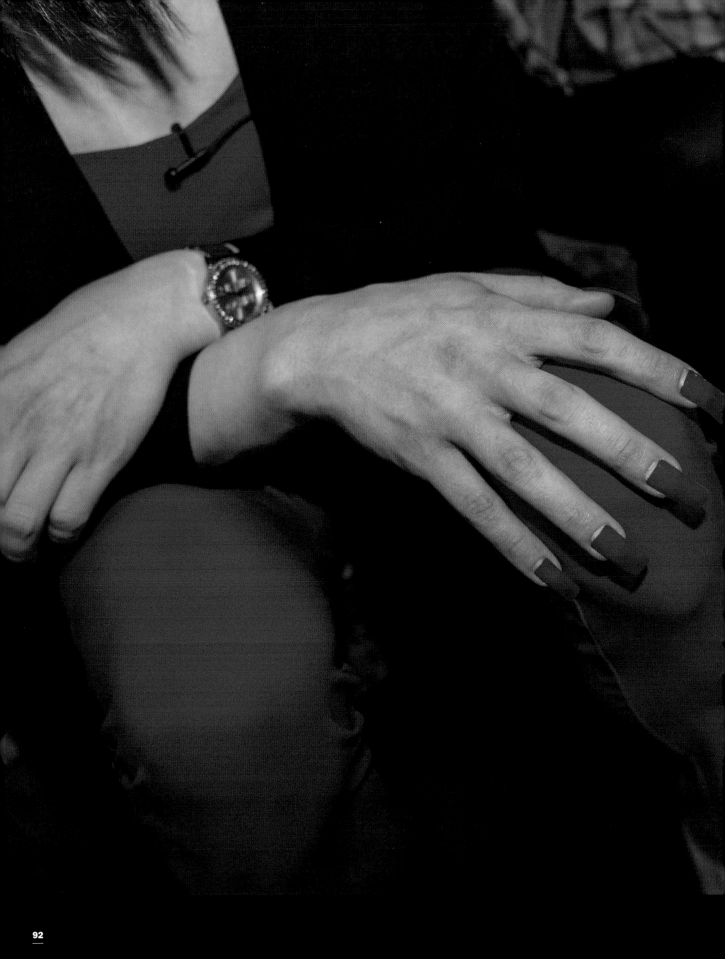

Štefica's first public appearance in more than a year.

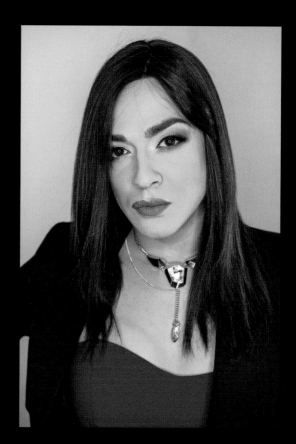

"I don't even know how to show love anymore. The switch inside me has been turned off, and I've forgotten how to turn it back on."

he wanted to exploit me, not because he was in love with me. I had some notoriety. People recognized me on the street. I was on TV. Filip enjoyed all that. He loved the spotlight. During that period, I was doing things I'm not proud of, but it was easy money, and I was making a lot of it. The job I was doing was paying our bills. It was an easy life for him. I feel like he never really loved me.

It takes so little to make me happy. If I really love someone, I can be happy with the smallest things: just sitting and talking to someone, occupying the same space, seeing that person in front of me. Here, as soon as people start dating, they run to the club and put on big public displays of affection so that everyone else can see they're together, that they're taken, that they have someone to show off. That's bizarre. For me, people who have to prove their love »

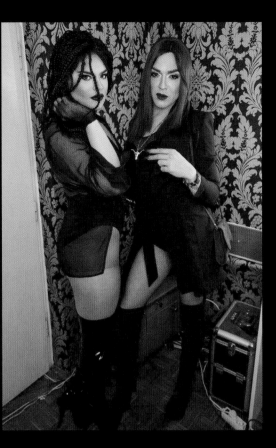

publicly like that run counter to what love is. For me, love is very private. I can show off a lover, a person I have sex with, but love, I keep for myself.

I lost the love of my sisters. I lost the love of my father early on—at least he never really knew how to show it. I lost the love of my mother, which I never overcame. I lost the love of my boyfriend, the doctor. He chose work over me. I lost what I thought was the love of my second boyfriend, Filip. At this point, I don't even know how to show love anymore. The switch inside me has been turned off, and I've forgotten how to turn it back on. I get hit on all the time by men and women. I get all kinds of offers from men, mostly of a sexual and transactional nature. That doesn't interest me. It doesn't excite me. I have nothing against a transactional relationship. It's fine. But let's not call it love.

What makes me happy? Small things. I do want material things, but the moment I get them, they usually lose all the value they appeared to have. I sometimes wish I could substitute emotional fulfillment with material fulfillment, but I can't. For me, love is a big deal. It's maybe the biggest deal. I want it, but I want the real deal, even though I ››

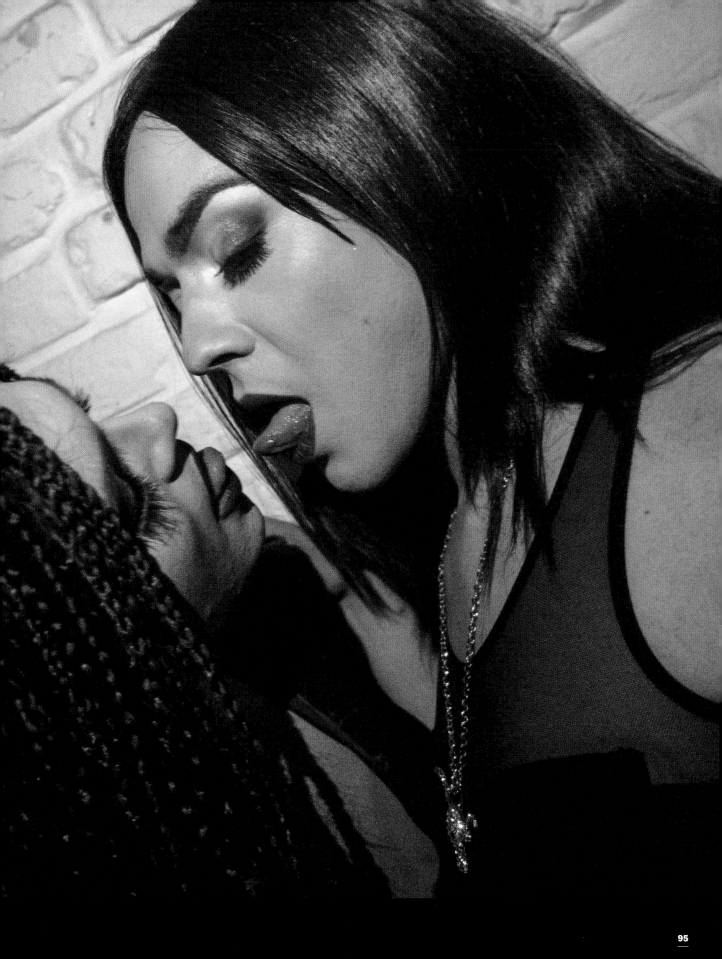

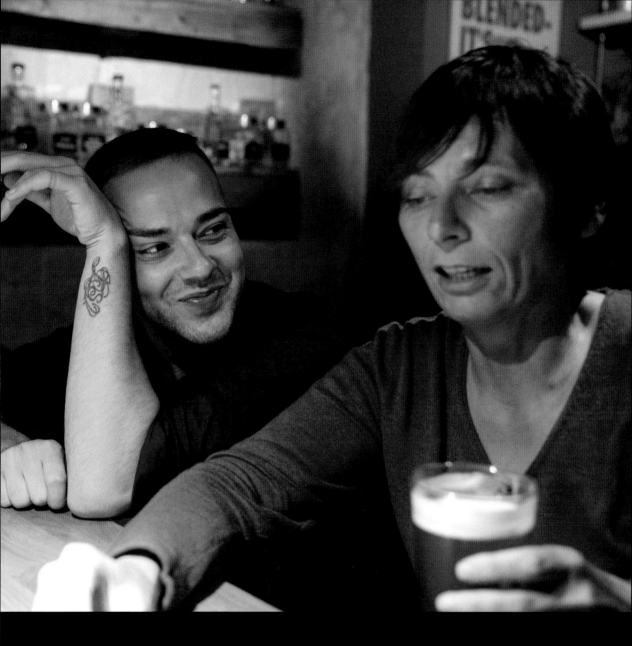

now have a hard time trusting people and giving myself to others. I want safety, protection, respect, reciprocated emotions, intimacy.

If I ever were to lose Vesna or her friendship, would I survive? Probably. I've lived through the loss of my entire family, so I'd probably survive that as well, but it may also be a breaking point. I might go crazy. She means too much to me.

I'd like to get married. I'm in no hurry—ten, twenty years from now, it doesn't matter when. I'd also like to be a parent. I'd like to bring up a child. With a partner or alone, I would like to make a child happy.

I don't see myself here in Serbia. I see myself here maybe for another four or five years. That's time to get a college degree and finish a few other things. I'm currently studying English. I know that without it I won't go far. Previously, I'd never thought about education. I'd never thought about my future. I had to make a living, survive, fight for everything, all the time. I made a lot of bad decisions.

I surrounded myself for a long time with negative people. I became one of those people. In the last year or so, I've learned to see different sides of people. I've met people who made me see myself differently.

Stefan with Vesna Zorić. Vesna is probably the most important person in Stefan's life—a friend, a mentor, and a mother figure.

I've come to understand what my potential is and how I can realize it. I need to work hard, but I know I can make it. There are a lot of people who are hoping I don't succeed. I'll prove them wrong.

I want to focus on activism. I want to fight for social justice and human rights for the sake of the many young, defenseless people I've met along the path, for my own sake, and for the sake of my sisters.

I was seven when I realized my sisters were different. My first year of school. They were fourteen. That's when my parents decided to send them away. Snežana and Suxana were born with Down syndrome.

They were blind and couldn't speak. My parents decided to send them to Stamnica, an institution that houses people with mental and physical impairments and disabilities. At the time, I couldn't understand why they were being sent away. After asking and asking them, my parents explained that it was for my benefit and my future, that kids in school wouldn't understand, and that it would be better for me if I didn't tell anyone that I had sisters at all. I still feel guilty because of that. I didn't have a choice. One day, they were just gone. Today, I think my parents used me as an excuse. My sisters needed constant ›

Stefan with his friend Rajka at the June Pride parade.

attention and care, and I think my parents decided to send them away because they were tired of dealing with them. I've always loved them.

I've been very protective of them. When my parents died I lost the guardianship of my sisters. I didn't have enough money, and they took them away from me. I stopped going to see them. I felt inadequate. I could barely provide for myself, let alone provide for them. A sense of powerlessness and guilt took over. But having spent time with them and seen how well they're taken care of, I've started thinking that my parents were maybe right, that they maybe knew that it was the best thing to do for my sisters. They are fed and taken care of, they are washed, and they have access to health care. If they had stayed with us, we couldn't have afforded to take such good care of them.

They are still my biggest inspiration to be a better person. I was afraid of facing them, but above all I was afraid of facing myself—my sense of guilt, my powerlessness. I was overwhelmed with emotion when my sisters recognized me, the physical affection they looked for. They're still in there, in those bodies. They didn't disappear. They're holding on tight to their existence, and if they can fight so hard, I can fight even harder to make my existence better. »

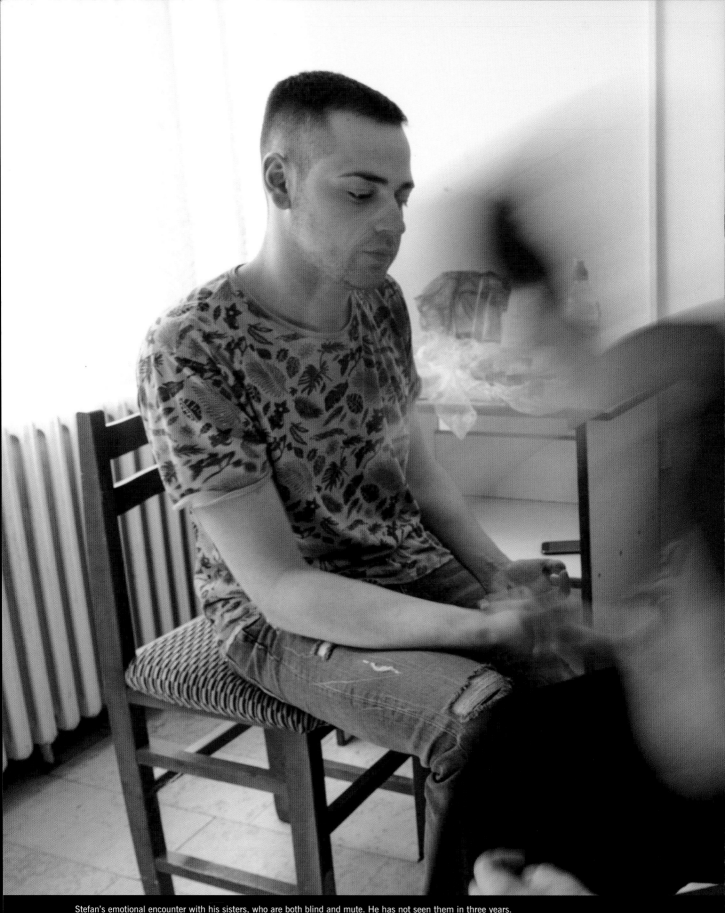

Stefan's emotional encounter with his sisters, who are both blind and mute. He has not seen them in three years.

> "I claim my freedom to be me without definitions, labels, or limitations. I am who I am—unapologetically—and if people have issues with that, it's not my problem. It's theirs."

My life has taught me that if something can go wrong it will probably go wrong. But I don't see how anything can stop me from achieving my goals. We all think that our lives are the most difficult, that our struggles are the greatest. But if we compare our struggles to other people's struggles, we usually find that we're more or less okay. The only thing I fear for is my health. After seeing my mother and father pass away. I'm scared the same thing may happen to me. Anything else can be fixed one way or another.

I was twenty-one when Štefica become part of me. I'd like to be buried dressed as Štefica, but I'd like my epitaph to carry both names: Stefan and Štefica. I feel that the woman inside me is strong. I feel her all the time. I'm both of them all the time. Maybe it's strange to some, but for me it's not.

People, activists, and even some friends see me as "not enough." It used to hurt me so much! Today, I claim my freedom to be me without definitions, labels, or limitations. I am who I am—unapologetically—and if people have issues with that, it's not my problem. It's theirs.

"This is my battle and I am winning.... I'll be all right."

Aleksandar Selmić

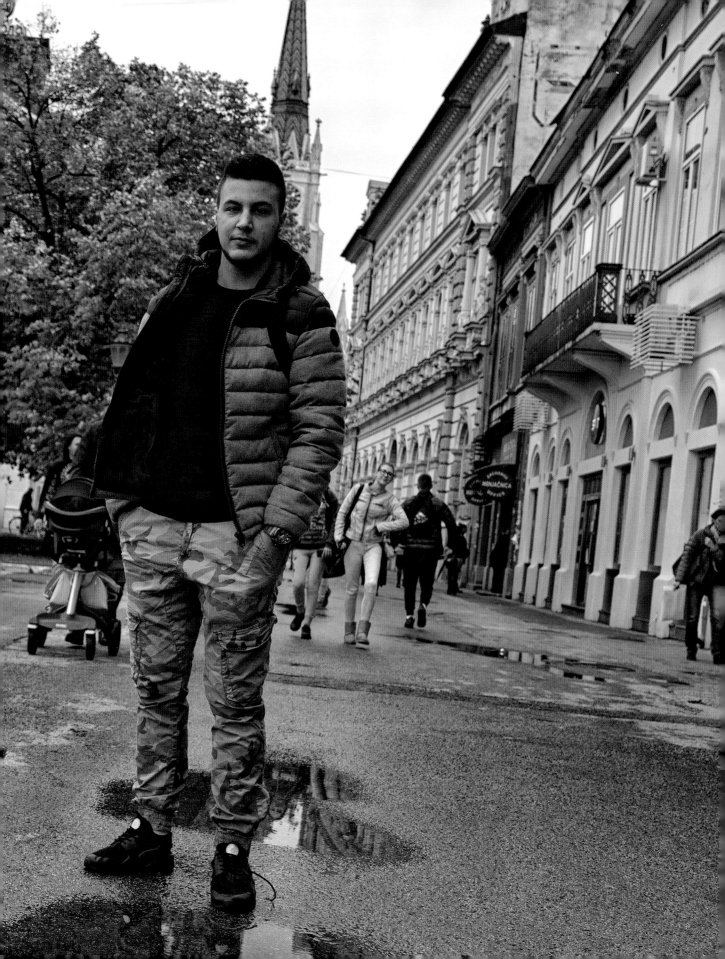

"There was only one way for me to exist—as a man."

I think I may stay in Novi Sad until the surgery. It's better for me to have my mother around. She'll help me. In Belgrade, I'd be on my own, which could complicate things. I have practically all the papers signed. Today, I finally received the okay from my endocrinologist. Now, it's just a matter of time. I still have to apply for government assistance. If I get it, the government will cover two-thirds of the cost of the surgery.

Around ten people get this in Serbia each year. It's not much. Most of the trans people in Serbia can't afford to pay for surgery, so they don't have any choice but to wait for help from the government. Sometimes people wait for years. I'm impatient. I'd go crazy waiting that long. Practically speaking, you have to have a psychological evaluation first. That takes anywhere from one to two years. After that, you go through hormone therapy. Depending on how your body reacts, that may take anywhere from a year to two or three years. After that, an endocrinologist signs off on the surgery. You take the documents to the commission, which issues a permit. Then, a surgeon decides when the surgery will be performed. The entire process can last from two and a half to five years. ››

"I don't know what I'd do without my mother's support. She gives me so much strength."

The government will cover two thirds of the cost of the surgery only if you do it all in one go—bilateral mastectomy, hysterectomy, and metoidioplasty. You can't do it in steps. It has to be done all together. Phalloplasty isn't covered. That would have to be done separately. Many trans men decide not to do it because it's so prohibitively expensive.

I'm hoping the surgery will be in April or May next year. I'm hoping it will all be done by next summer, and I'll be in great shape!

People used to treat me terribly. Even at work, people kept addressing me as female, and one of my colleagues even threatened to beat me up. Now, people have calmed down a little bit and leave me in peace. The biggest issue I have is with my ID. Two days ago, a couple of my friends and I were stopped by the police for a random ID check. My friends handed over their IDs and it was okay. When I gave them mine, the police officers got upset. They thought I was giving them a fake ID or playing some kind of a joke. I clearly look like a man, but my ID still has my birth name and says I am female. They told me I had to go to the police station with them and give a statement as to why I had someone else's ID. I refused. I told them I was a trans man in the process of transitioning and that the ID I'd given them was mine. The argument went on for another thirty minutes before they called some colleagues from another department and more police officers showed

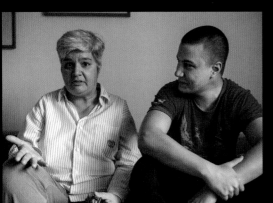

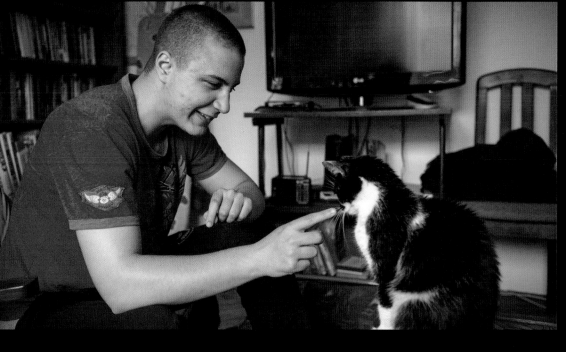

up. In the end, there were eight police officers surrounding me, as well as a group of curious people trying to figure out what was happening. I was really upset. Finally, they decided to believe what I was saying and let me go, but they were not happy about it. They kept me there, in the middle of the street, for at least an hour. These are some of the horrors you have to face as a trans person in Serbia.

I knew I was a man very early. It was before my female puberty kicked in. I'd always had very short hair. My style was always quite masculine. The Internet helped me understand what it meant to be a trans person. But it was when I met an older trans guy, who was already taking hormones and was well into transitioning, that things became crystal clear. I knew what I was, and it all made sense. I was a trans man.

Female puberty destroyed me. Male puberty is totally different, physically, psychologically. I enjoy it. I've had many issues with discrimination and bullying, but that's external, environmental. I could always remove myself from that. Female puberty was an internal thing. It was like I was fighting myself in a battle that I couldn't win no matter how hard I tried. And the fighting never stopped.

People would always ask me when I'd let my hair grow or when I'd stop wearing men's clothes and become more feminine. Can you imagine? For me, that was never even a remote possibility. There was only one way for me to exist—as a man. I'm finally getting to the point where I can just be me the way I feel like being me, and I don't care anymore about what people think or say. I'm fighting hard for it, and I'm owning every single bit of it.

My dad used to be involved in some kind of criminal activity. He and my mom split maybe ten years ago. I grew up with him, but since they divorced, I haven't seen much of him. In the beginning, I saw him maybe once a year, but after a few years he just totally vanished. He was gambling and was heavily in debt, and he just had to disappear. I haven't had any contact with him in many years.

My mom is amazing. She's a real intellectual, a bookworm, a smart woman. She's always treated me with respect, and she's never tried to impose things on me. I feel that she accepted me from the beginning. She would always tell me that I could be or do anything, except use drugs. [laughs] I literally don't know a single trans person who's had that kind of support from their families, and believe me, I've met quite a few. It's so sad. I don't know what I'd do without my mother's support. She gives me so much strength.

I'm studying to be a physical therapist. After I finish school, I'll do an additional year at a college that specializes in physical education. I'd like to work as a personal trainer and physical therapist. I have a ›

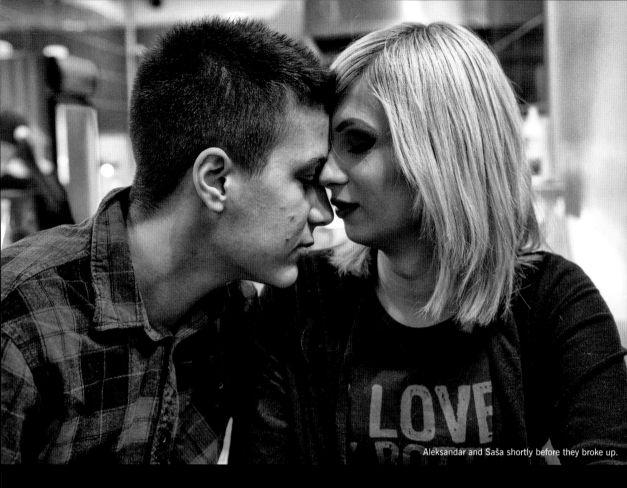
Aleksandar and Saša shortly before they broke up.

good understanding of the human body. I'm good at what I do, and I'd like to help others. I don't feel like staying in Serbia, mostly because the economic and professional prospects here aren't great. There's a lot of apathy and exploitation. I'd leave if I could. It depends on a lot of things I can't control, but I'll do everything in my power to leave this place. I need to finish school first. Education is paramount to me. I also have to finish transitioning and put that whole thing behind me. Once all that's done, I can start living like everyone else, and I can plan more concretely what I'll do.

I'm not dating at the moment. I don't have the stamina to focus on that. There's always too much drama, and I need to focus my energy on other things. I mean, I'd like to have a person in my life; I'd like to fall in love and be loved, but now is not the right moment for that, that's all. There'll be time for that—once I'm all settled.

I'm not scared. I know the surgery will happen soon, we have good doctors here, and it should go well. The school I'm in is an okay school, and it's recognized abroad. I'll have a valid degree to work somewhere else, and I'll have a skill set that's always

in demand. I'm confident I'll find a way to make a decent living. I'm a hard worker and have a simple lifestyle. I've managed to save some money, and it should be enough to cover the medical costs. If need be, my mom will help me if she can. But this is my battle, and I'm winning. I'll be all right.

In the months after our conversation, Alexander would occasionally text me:
OCTOBER 13
I need to go for another medical check-up in November. For now, everything is okay. I wanted to apply for medical coverage in December, but the doctor is treating me terribly. They have a couple of patients they're favoring and pushing for urgent surgery. As for the rest of us, they don't give a fuck. The endocrinologist has signed off on everything, the gynecologist as well. I tested negative for HIV, so all good there. My psychiatrist has signed the authorization for the surgery, but apparently I need the opinion of two psychiatrists, so now I'm waiting for her signature. It's literally the only thing left to do.

I've gone to see the second psychiatrist. I feel like she's mocking me. It's the third time I'm seeing

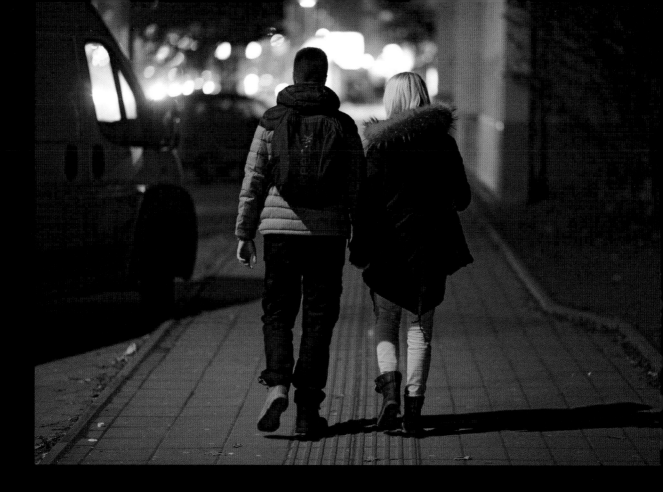

her. Her authorization is the only document I'm missing to qualify for coverage. She's put me on a new medication for anxiety. Each time, she tells me she'll give me the authorization "next time." I'm anxious because she's putting things off while more and more people are applying for coverage for 2018. I need to apply as soon as possible. It's so unfair. Sorry for the rant.

OCTOBER 26

I went to see the doctor today. He told me I need to return in January so we can book the surgery date, but he also told me that everything is fully booked until June or July. He was in a really bad mood. He barely spoke to me. I don't really know what to think at this point.

NOVEMBER 1

I passed the evaluation. They called me this morning! :-) He told me to come back in January for the dates for the surgery, but that it's definitely going to be after June. It seems so far away. I've done everything I can. Now, I only have to wait.

NOVEMBER 22

Sorry to bother you. I wouldn't if it wasn't urgent. I spoke this morning with the surgeon. He claims that he won't be able to operate on me in 2018. He claims that all the slots for 2018 are taken. I'm about to have a nervous breakdown. I have no one else to talk to about this. Should I do it at a private clinic? I can't wait until 2019. I'll go insane. I don't have money for the surgery. Maybe selling a kidney would help. That way I could afford to do it privately. 2019 is too far away.

NOVEMBER 25

I spoke to my mom. We found a private clinic where they can do a bilateral mastectomy for 2,300 Euro. I have a thousand, and my mom has another thousand. I still need to find another three hundred, and I could do it. The surgery would be around the end of January. I spoke to a couple of people who've had their surgeries done there, and they're happy with the results. I have to get rid of my breasts as soon as possible. I have scoliosis, and my back is starting to kill me. The binder is causing me all sorts of respiratory problems. I can't go another summer like this. ››

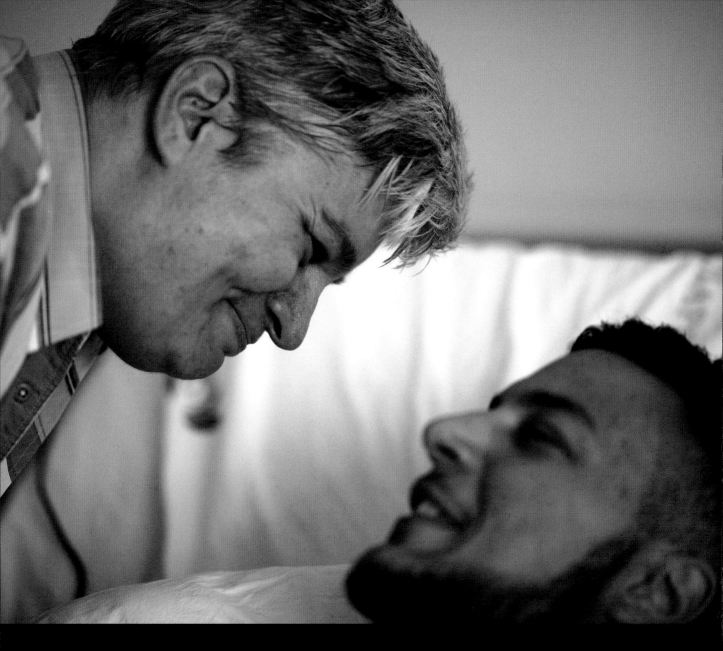

DECEMBER 6

I need your advice. I've asked around and many people have told me to wait and see if they can still manage to operate on me in 2018. They say that sometimes the doctors are bluffing, to see if a person will be desperate enough to do the surgery privately. Sometimes it works, other times it doesn't. I've been told to go to the doctor as often as I can, until he gets tired of me. I don't know. I can't spend another summer in this binder. On the other hand 2,300 Euro is a huge amount for me. I'm so depressed because

of the way they're treating me. What would you do in my place? At this point, I'm losing all hope. Why are they not letting me be happy?

DECEMBER 7

They told me I shouldn't be "throwing money away" on surgery at another clinic and that they will manage to squeeze me into a 2018 slot. The doctor was in a good mood today and really nice to me. I'm so relieved. It's like a rock has been taken off my chest. They also told me that I look good. Ha!

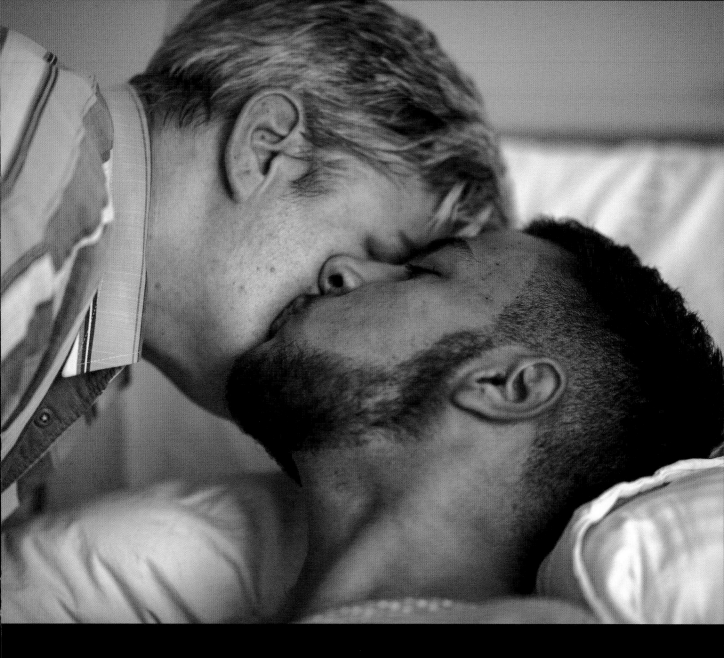

JUNE

After a few years of psychiatric evaluations and hormone therapy, Aleksandar has completed the first of two steps in his gender-affirming procedure. Aleksandar's mother, who is incredibly supportive of her son, is there every step of the way during this long and difficult process.

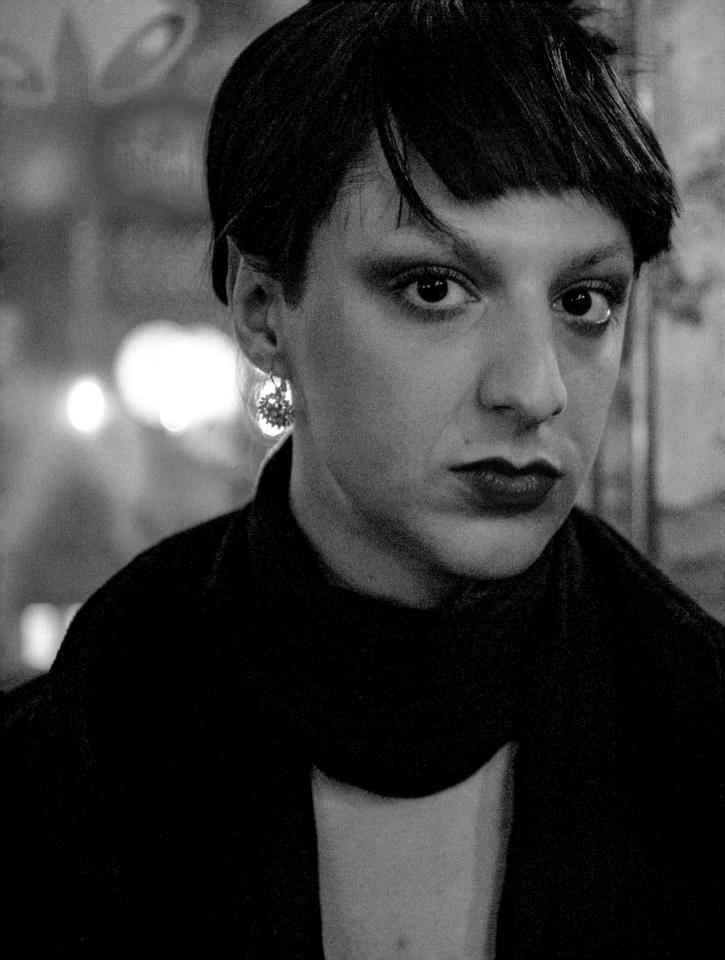

"I publicly fight the stigma."

Sonja Sajzor

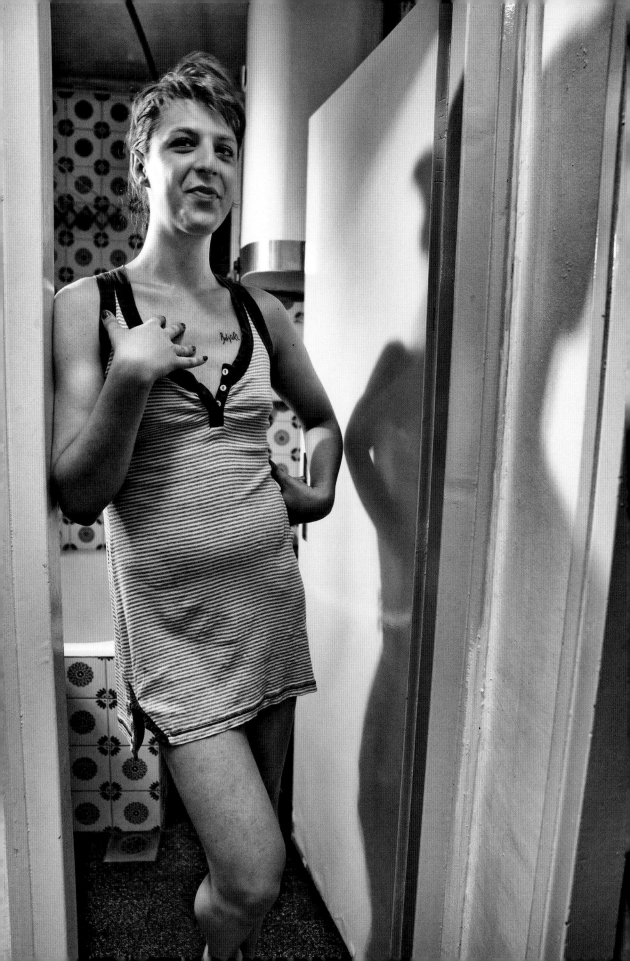

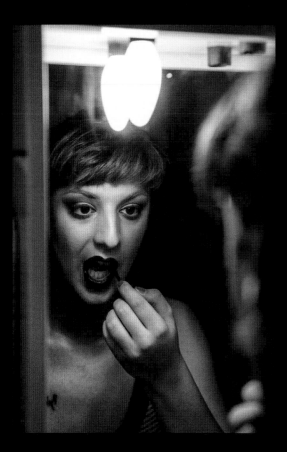

"Look, I'm not perfect, but I think that I'm a great person. I feel like men should fight over me."

I've never really had a boyfriend. I mean, I've been with guys, of course, but they were never my boyfriends. You know, if you're a trans woman, guys are weird with you. You're like a fetish to them. You know how many times guys told me, "I'd like to try a trans chick," which most of the times translated to "I'd like to suck a cock and maybe get fucked." They don't look at me as a person; they perceive me as a sexual object, something that can fulfill their fantasies, and that's about it. I am sure there are exceptions and that all men interested in trans women are not the same, but this is my personal experience.

I'm getting so sick of these straight-wannabe guys who act like that. They're in all sorts of personal denial. They tell me that I'm smart, that I'm interesting, that I have good style, that I smell good, that I'm successful—all great things—but they also tell me, "Sorry, you're also trans, and I can't be seen with a trans woman." I put so much effort into looking good, into building myself as a person. I'm funny, I'm sexy, I can be a good girl but also a bad girl. Men love it, and we have a great time together, but then they tell me, "You're amazing, just don't share photos of us on social media. Who

knows what people are going to think?" A week later, you see them on Instagram with a totally basic woman—bleached hair, silicon lips, just bland all around—and they appear to be happy to share their photos together. It's depressing. I never seem to be good enough for anyone. Look, I don't need a man by my side to make me feel successful, but I do need affection and romance, and I do want a man who can love me for who I am.

Look, I'm not perfect, but I think that I'm a great person. I feel like men should fight over me. But I always bring myself down. I am my own worst enemy. Take this one guy, for example. I've liked him for about a year and a half now. Every time I want to do something more with him, to make it clear to him that I'm really into him, I tell myself: "Be patient, start with baby steps." After a year, I'm still taking baby steps, and I'm asking myself, "Why the hell do I need to take baby steps?" I just don't have enough confidence in myself to make it clear to him that I like him. It's almost as if I'm afraid that he'll reject me.

I was thinking about going back to working as a bartender. I spoke to the owner of the cafe where I spend a lot of time. I know him well, and I asked »

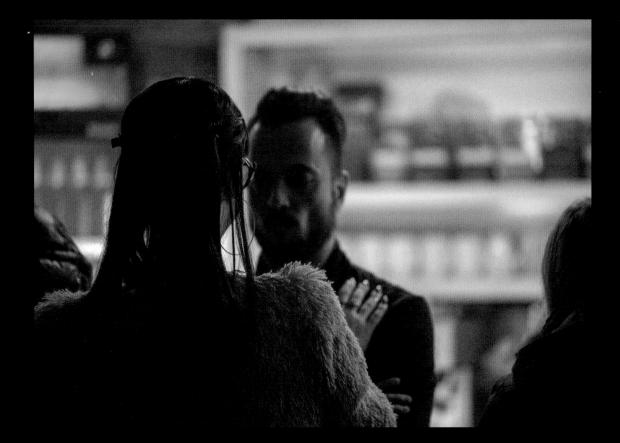

him to give me a job as a bartender. He told me that if he could he would, but that his business partner has some issues with having a trans woman working there. I couldn't believe it. I think it actually has nothing to do with his partner. I think he's the one who has a problem with it. It's so disappointing. Needless to say, I can't have anything to do with transphobic people, period. I'm out of there. I'm still looking for a job. It's a struggle, and producing my album and music videos is expensive, but I'm confident I'll find a way to do it. I always succeed.

When I enter a room, if people know about me and know that I'm trans, they expect me to be less capable, to not have great and creative ideas. Somehow, they identify being trans with inferiority. But then, after I've spoken to them and after they've heard what I have to say, I come across as eloquent and creative, as professional. People look at me, and they are fascinated by the fact that I manage to rise above prejudice and manage to be good and successful even as I'm being hammered down.

When I'm in front of other people—I hate to say it—I often see myself as better, as someone with more creative ideas, as somebody who is willing

to work harder and push things further, somebody who has a more open-minded perception of the world. You know, even when I talk to feminists here, they don't really understand the whole trans thing. They just don't get it, and often I feel like they don't want to get it. Or some trans people I talk to, they don't understand racism; they're utterly clueless. Or people of color who don't understand queer theory. I try to see it from different perspectives, and I often see myself at a much higher level of awareness. Internally, I see myself as not good enough because I always strive for perfection.

I openly identify as a trans woman—an outsider, punk rock, a kid. I self-identity as eternally misunderstood and eternally rebellious against injustice. I publicly fight the stigma. I want to educate people. But sometimes I just want to go and have a sandwich, or I just want to go to a post office, and not make it into a big political statement or a big deal. Sometimes it's frustrating that everything in my life has to become this gigantic political statement. I have to fight for my rights all the time—even for the right to just be, to exist. For many people, mine is not an existence worth supporting or tolerating. When I »

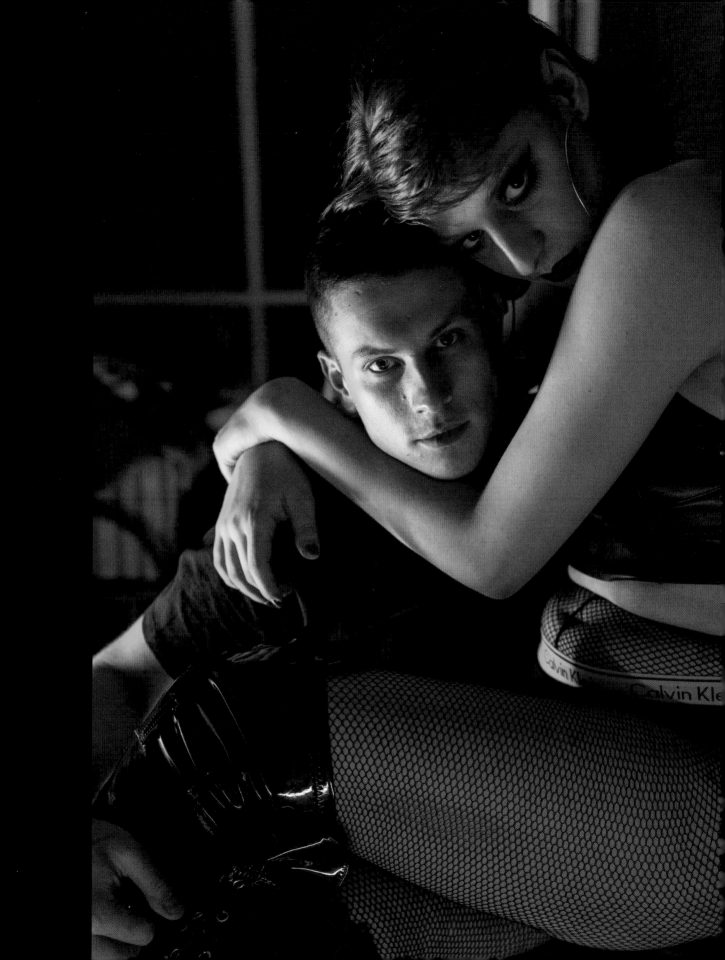

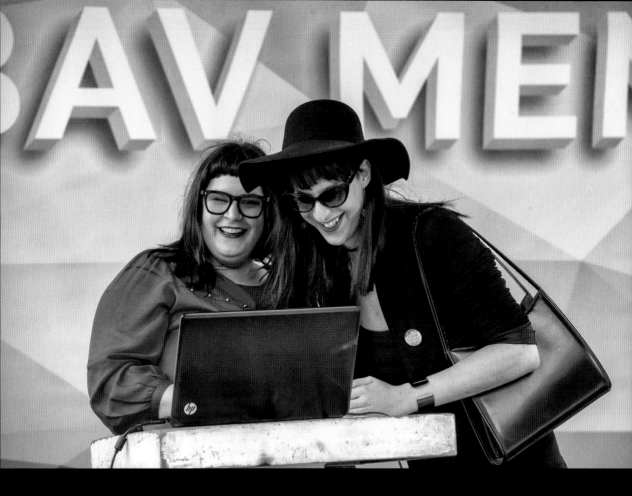

> **"I have to fight for my rights all the time—even for the right to just be, to exist."**

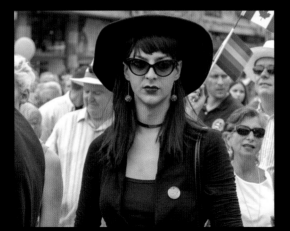

wake up in the morning, I'm not this superwoman. I have no makeup on, my hair is undone, and I go to the supermarket around the corner to grab some milk and coffee, and I'm faced by a rude cashier staring at me. I get frustrated not so much because people discriminate against me but more because the law does not protect me. Often, it makes me not want to go anywhere. If only I had the right to change my name to a female name and change my gender marker in my ID . . .

I don't see myself as an activist. I see myself as just a person, living and creating, doing my job and doing what I love. And then I come across people who say no to me because they don't want a job to be done by a trans person. That's when I get frustrated and use my platform to talk publicly about my experience. Some people may see it as activism, but I don't do it necessarily to make the world a better place. I do it because I want to live my life freely and be respected and not discriminated against. I read online what's happening, and I tweet about how unfair things are. I spread the word and try to raise awareness, but I don't have the capacity or stability to be a full-time activist.

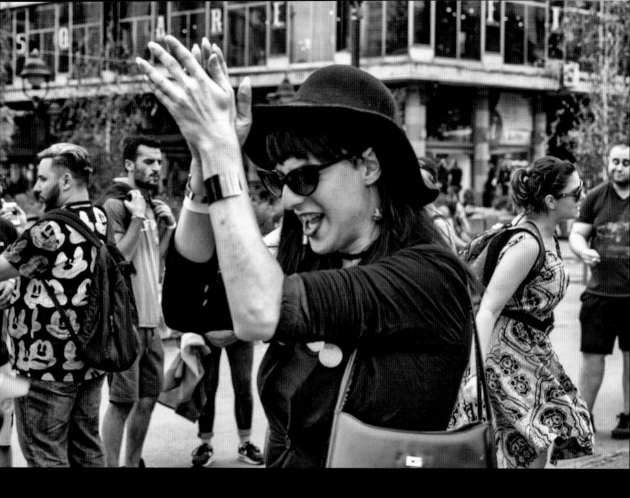

I started my career as a drag queen. Once I started transitioning, I was kicked out of the drag scene, a scene I pretty much created here. It's ridiculous. No one has the right to determine who can do drag and who can't. It's like telling me, "You're not a gay man, you're a trans woman, so you're not allowed to be creative." What the actual fuck! I talked to drag performers about this before I came out as trans, and what they told me is that for them being a trans woman who does drag is like cheating. We take hormones, and that gives us an unfair advantage, like doping in sports. For me, drag is not about looking like a woman. It's about being fierce! I design my own costumes, I style myself, I do my own hair and makeup, I even do my own art directing and lighting for my photo shoots. I'm capable of doing all these things, and taking hormones is certainly not going to help me do any of these things better. So, when the drag community excommunicated me, I just Beyoncé-d out and started doing my own thing.

At the end of the day, I'm quite simple. For now, I just want someone to cuddle with, someone to spoon me at night and talk to me and listen. I don't expect anything special, really. I've dated some guys who weren't the smartest, but they were really hot. I've dated super smart guys who were totally average physically. I don't know; I try to see the good in people—I like good people. I just want someone who's going to want me as much as I want him. I don't want to be in a relationship where I need to ask a guy, "Why haven't you kissed me today?" I want this person to be impatient to kiss me when he gets home, to desire me.

I feel very loved by my mom and my aunt, but at the same time I don't feel loved by them. They still refer to me by my old name, a male name. They give me male-specific compliments. They don't know who I really am, and it's not like I'm hiding it—I'm pretty open about everything. They know everything, they get it, but they are passive-aggressive with me, and I don't really understand why. It seems that they need more time to adjust, but I'm getting more and more impatient. My aunt has a boyfriend, who keeps referring to me with male pronouns and uses my old male name. Even when they come to visit me, and I am in full hair and full women's clothing, he still calls me by my male name. My aunt thinks that I should be grateful that he is even trying, but I feel that he's ››

not trying hard enough. If I were a cis woman who got married, he would have picked up my new surname in no time. He respects marriage, but he doesn't respect a person's being trans. I am not putting up with people disrespecting me, I'm sorry.

Living in a small village made me a very naive person. I trusted everyone. I thought that everyone was genuine and honest. Then, I moved to Belgrade, where people kept screwing me over. Guys screwed me over, people at work screwed me over, friends fucked me over. I've been hurt and betrayed more

times than I'd like to remember. I think that was one of the most difficult things for me—adjusting to the big city, where people's relationships are quite complex. I had to lose my naiveté and toughen up, while trying to still be honest and a good person. It's hard, because people here really test you all the time. You have to be strong to survive. You have to project a certain image. Nobody likes losers.

I just want to be able to do the things I want to do with dignity, without prejudice, while feeling safe. Normal things. Things all people want, to do a

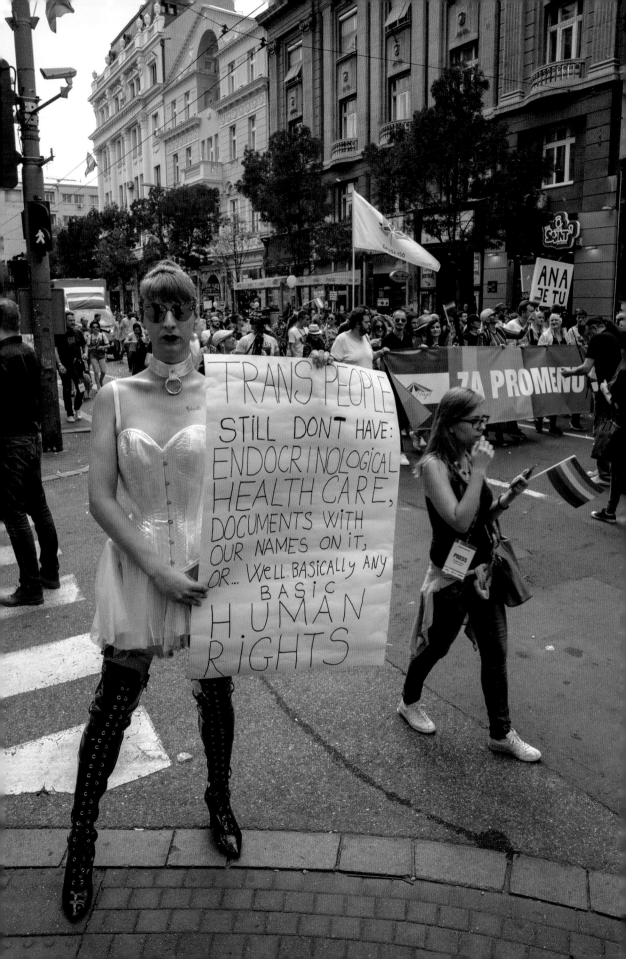

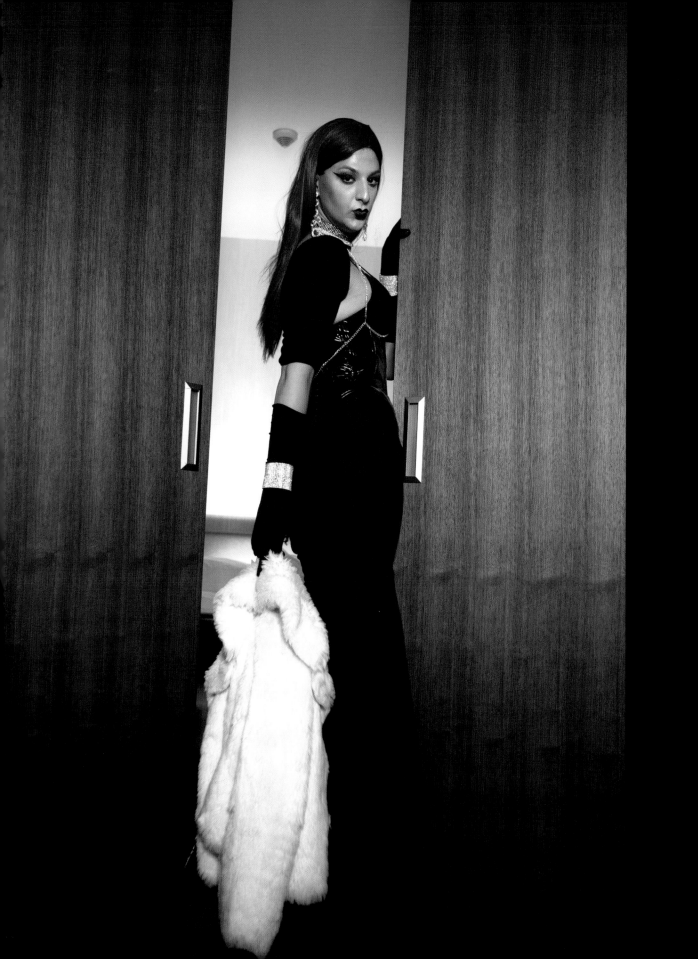

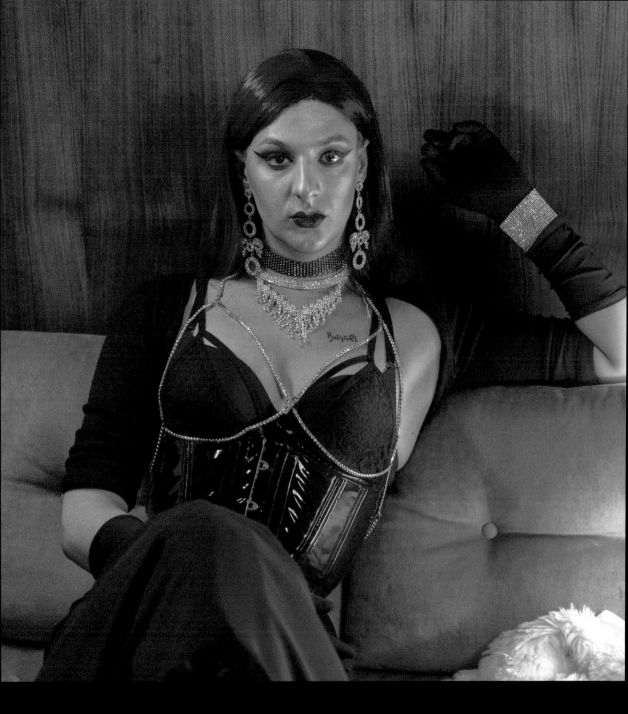

job I want to do, to travel, have basic human rights, use the restroom safely, without being scared that someone is going to make a scene and yell at me, or worse, beat me up. I don't have some super-amazing great ambition. I just want simple things and to not be stressed about it all the time.

I experience a lot of things because I am trans. One of the craziest situations was when I recently had this lump on my breast. I was freaking out. I get so paranoid about my health, and I couldn't find a doctor who would treat me, because I'm a

trans woman, and most doctors have no experience working with trans people; plus, they don't want to have that kind of responsibility. I was in fear for months about that lump. I got so scared, I thought I had breast cancer and nobody gave a damn about it, especially the doctors I saw. My father died of cancer at a very young age, a little older than I am today. The fear of cancer haunts me.

I fear for my health, but I'm also afraid of pain, of violence, of hurting somebody in self-defense and going to a male prison. You hear these horrifying ››

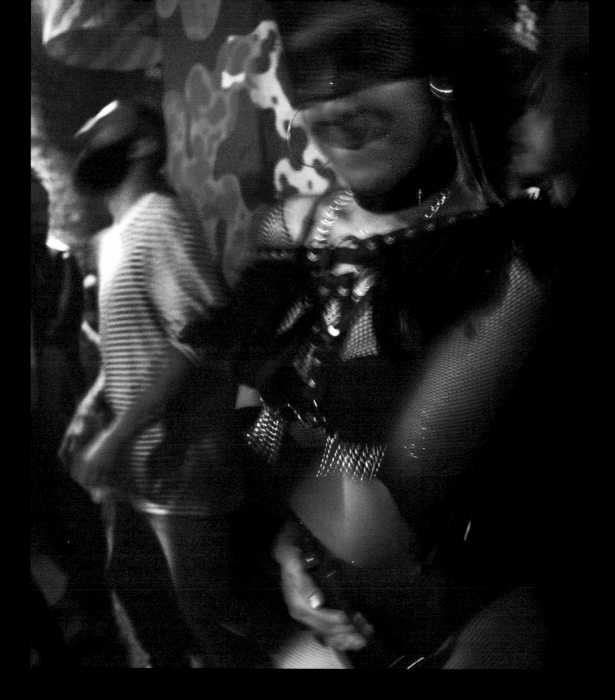

"I publicly fight the stigma. I want to educate people. But sometimes I just want to go and have a sandwich, or I just want to go to a post office, and not make it into a big political statement or a big deal."

stories of trans women in prison, and I am afraid that I may end up like them.

The other night, I was so depressed and down. At some point, I just thought, fuck this, I'm going out, and I'm going to have fun. I got my red lipstick and wrote on my mirror: "I am not going to be bitter." I put on some makeup and went out. That night, I met this guy. He seemed different. He was attracted to femininity. He was equally attracted to women, trans women, and very feminine guys. It was different with him. He held my hand while we were walking on the street. It was my first time ever. Can you imagine?

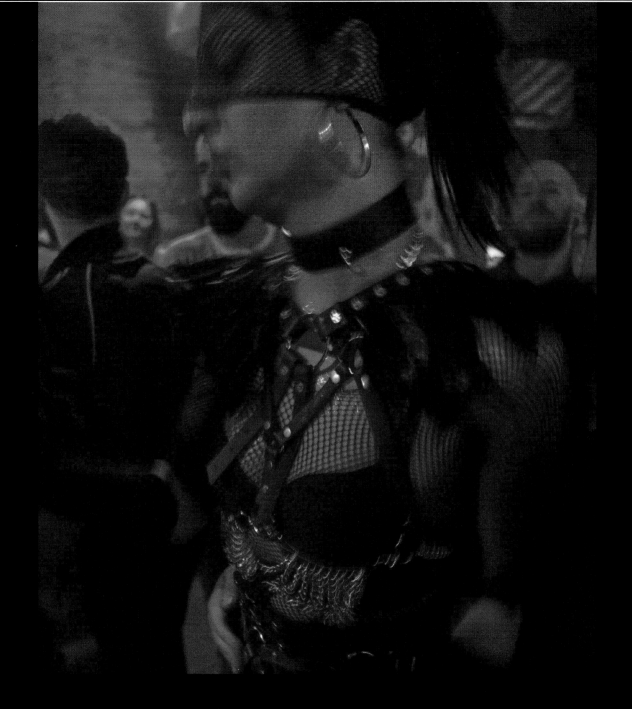

I'm fucking twenty-four years old and no one has ever held my hand on the street before, ever. It felt amazing. I felt like I was in heaven. In a weird way, it was such an achievement for me. It's almost pathetic that such a small thing that everyone else takes for granted was such a big deal for me. That night, he got really drunk, and I offered to take him to my place, but I clarified that we could only cuddle, no sex that night. We cuddled and woke up really late, and we just kept cuddling and kissing. I enjoyed that so much. I've never spent an entire night with a guy before. Normally, they come over, and after they're

done they can't leave quickly enough. It seems that, once the fantasy is realized, they don't have the slightest interest in me as a person. So, after spending most of the morning together, he left, and I was certain I would never see him again.

But he called me and we went out to a club, and he kind of refused to kiss me the entire night. Needless to say, I was hurt. At some point, I ran out, and he followed me outside. I started crying, and he hugged me. I told him that I didn't want to be with someone who was embarrassed of kissing me in public, and he said that he felt uncomfortable with ››

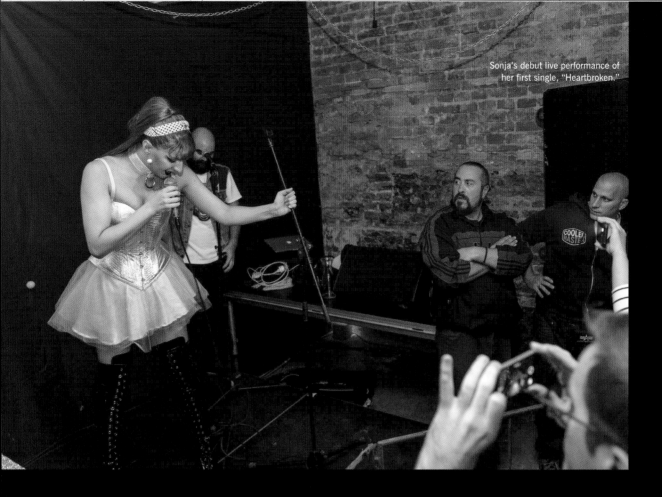

any kind of public display of affection and that it had nothing to do with my being trans. I don't know, I was really upset.

We spent more time together, but then he had to go back home. Now he is not here, and I miss him. He texted: he thought his parents knew about us. Somehow they'd found out. He thought they'd looked on his computer. I was so afraid for him. He lives on a farm; his parents are from Bosnia and are so religions and intolerant. You know, he's twenty-one, and when he's home, his parents still control his cell phone and his computer. I was really nervous. I was afraid to text him, to email him. I didn't know if they were looking at his messages. I know that I was totally paranoid, but you hear all kinds of crazy stories here about parents doing horrific things to their queer children.

Finally, I got a message: he and his parents had had a big fight, and they'd kicked him out of the house; he was looking for a way to get to Belgrade and stay with me. Then, I got another message that he couldn't leave, because his mother was threatening to kill herself if he left the house. So much drama. He knows that, independent from our

relationship, he'll have to leave that place if he wants to have any kind of fulfilling and productive life, so we'll see. For now, my hands are tied. I don't know what to do or how to help him. I guess I just have to calm down and be patient.

I remember, when I was a child—I can't recall if it was in kindergarten or first grade—they took us to see the animals at Belgrade Zoo. The day was lovely, the sun was shining, it was peaceful. To everyone else, I was just a boy mesmerized by the animals, but in my head, things were gray and cloudy. I knew I was a girl, I felt like a girl, and I knew I wanted someone all for myself, someone who would want me as his girl, all for himself—a boyfriend. In my head, I could picture my future self on the other side of the bars: a beautiful woman with her boyfriend by her side. He was holding her hand gently, as if he were afraid it might break. She was staring at me and nodding her head in approval as if to tell me, "It's all right, baby girl, it will happen, you'll be fine, just be strong and patient."

I told my boyfriend about it. He didn't make much of it at the time, but a couple of days later, we were going for a walk, just walking around, no big ››

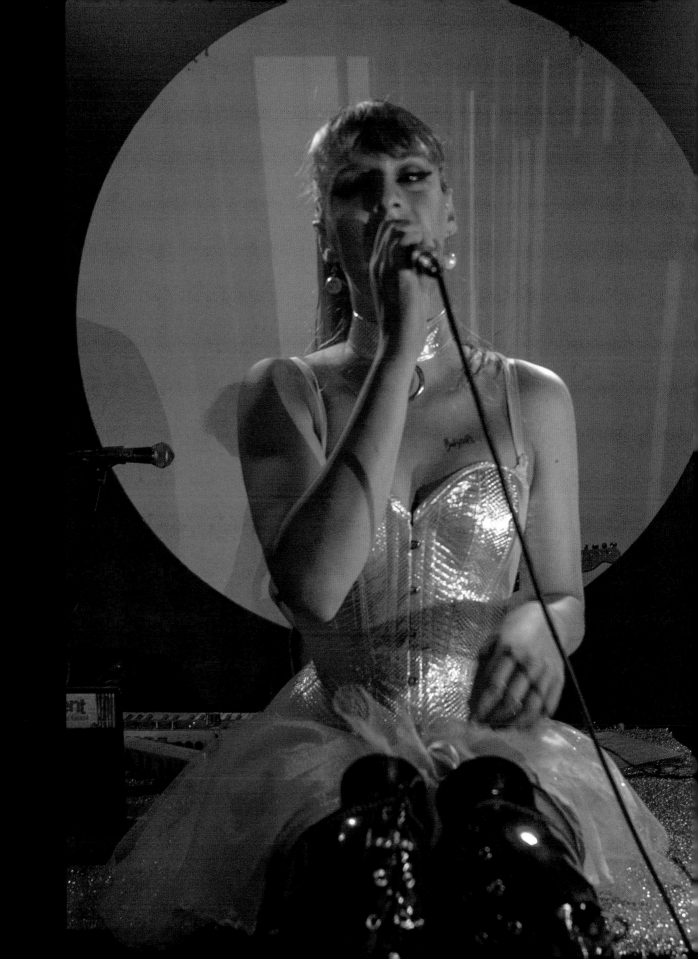

deal. Then, I remembered how many times I'd walked there, by myself, feeling a terrible sense of loneliness and sadness, first for not being seen and accepted as a woman, and second for not having anyone in my life who loved me the way I wanted to be loved.

I grew up with my mom and my aunt. At some point, my aunt left to live with her boyfriend, and shortly after, I moved to Belgrade, which left my mom on her own. Occasionally, my mom would show me photos that she, her sister, and her sister's boyfriend took together on some of their trips. I was always so surprised by how ordinary those photos were— just random photos in front of random monuments, statues in parks, bridges, places that I'd normally consider boring and inconsequential, not worth remembering. I never really understood my mom's desire to memorialize those moments until that day

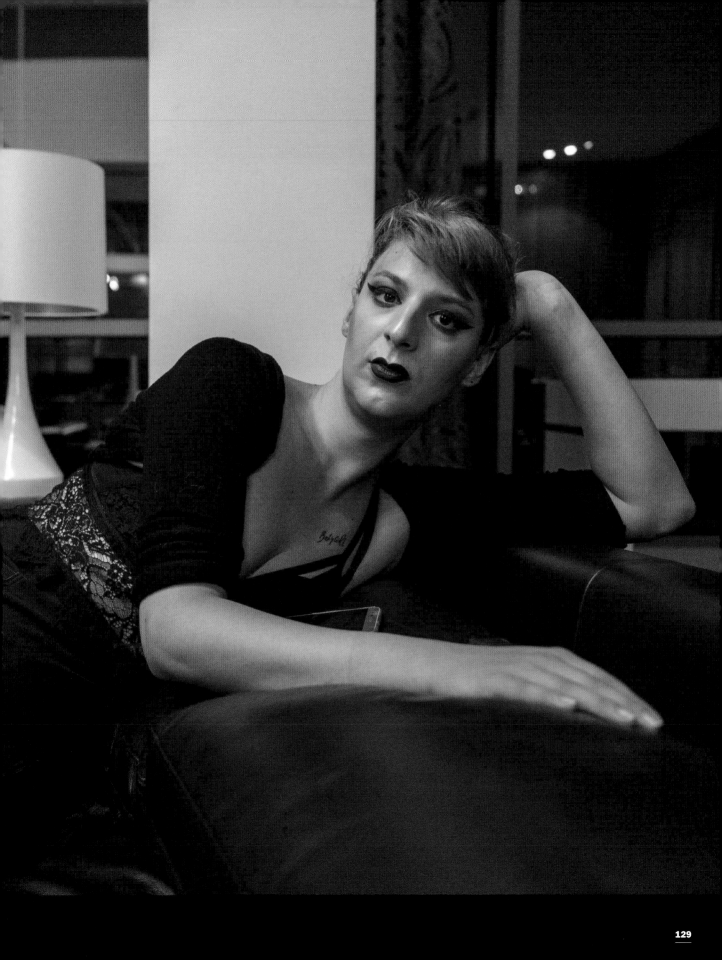

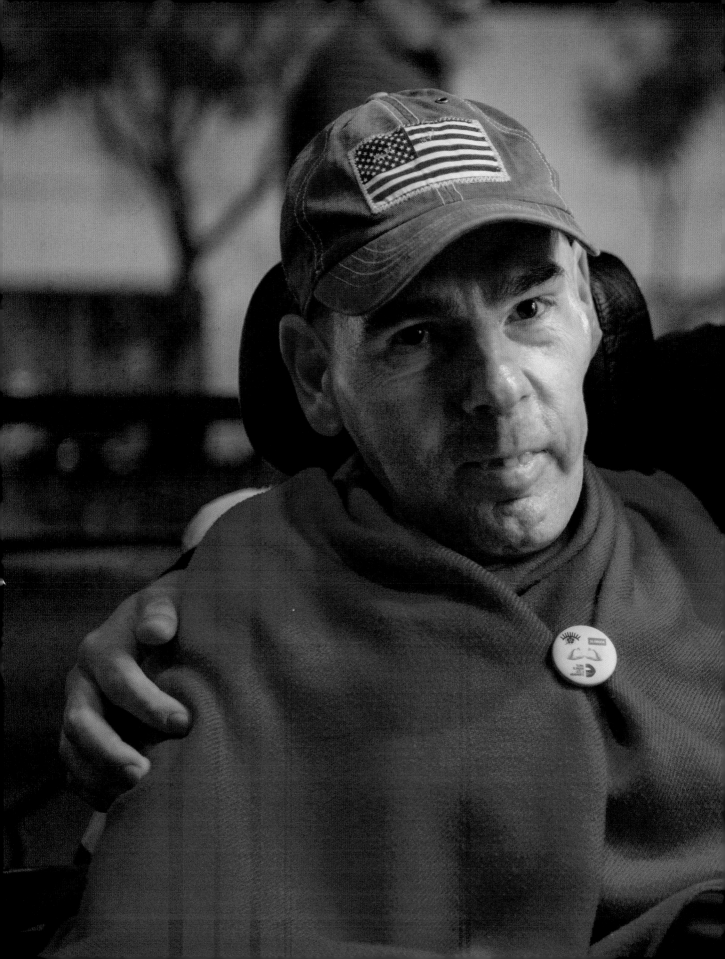

"People never stopped hating."

Nenad Mihailović & Bojan Babić

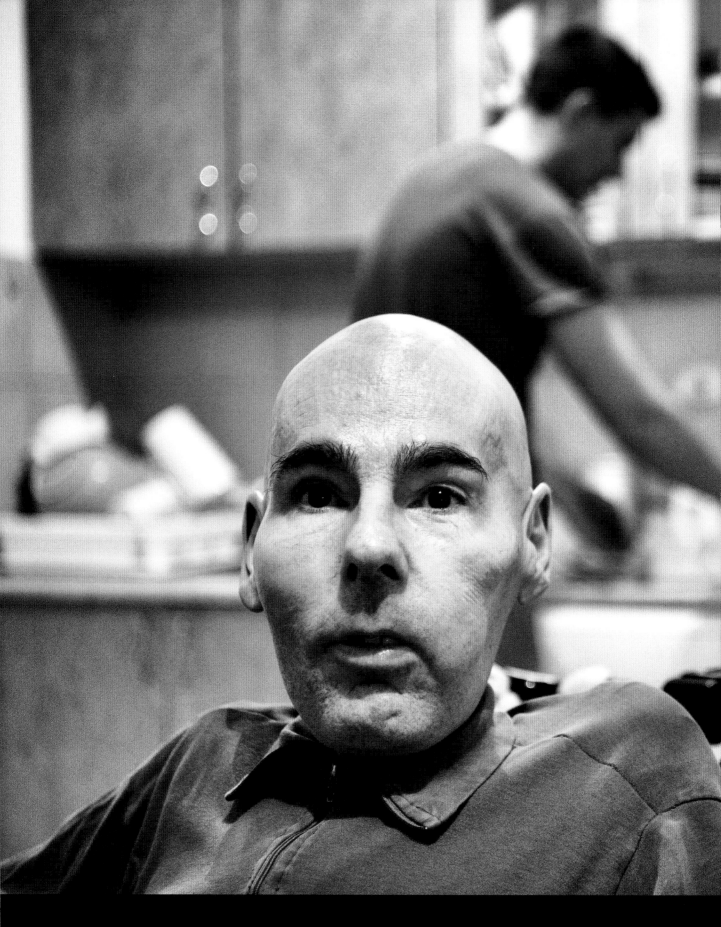

Nenad Mihailović I wanted you to photograph me in my work environment, but I'm really not in any condition to do it. My health is getting so bad I can barely do anything. I have a good doctor; she's quite famous. We don't agree politically at all—she's a nationalist and homophobic—but she is a good person and a great doctor. It's almost entertaining: she's treating my spinal muscular atrophy, and I'm treating her homophobia. We're both benefiting from this.

I'm a video blogger. I work mostly exposing corruption, hypocrisy, homophobia, and misogyny in politics, the Orthodox Church, and the media. That's why people hate me so much, and that is why we get threats, including death threats.

There's still a lot of homophobia in Serbia. Everyone is so afraid to come out. People are horrified of the consequences. For example, I knew this guy, Marko, a son of a prominent politician. One day, Marko came to study for a college exam with my boyfriend, who wasn't at home when he arrived. I knew Marko quite well; he was an attractive young man and a very good student, and I'd always had a suspicion that he might be gay, but he never spoke about it. So I asked him. My boyfriend and I were openly gay, and I couldn't understand why »

"My mother beat God into me when she discovered I was gay."

Marko didn't feel like he was in a safe space with us. Instead of replying to me, he just smiled. I interpreted that as a yes. That was the last time I saw him. He was afraid that I would expose him, so he decided to sever all contact with me. So sad.

My mother beat God into me when she discovered I was gay. She was the most violent person in my life. I haven't endured abuse like that from anyone else. Many people say that fathers are more violent, but in my case it was my mother. She tormented me for being in a wheelchair. She always felt that she had nothing to do with the way I was born, with my physical disability. She blamed me, and she never missed an opportunity to make me pay for it. When I was a child, a kid in a wheelchair, she would beat me up, not stopping until her hands were covered with the blood gushing from my nose. Just pause for a second and paint that picture in your head. My own mother— a person who was supposed to protect me, to nurture and nourish me—was my tormentor.

The beatings went on for a long time. One day, my best friend, who was like my older brother, asked me why my face was bruised. I confessed that my mother was beating me up, and he looked at me and promised it would never happen again. It never did

happen again. Later, I learned that he had gone to my mother and told her that if he ever again saw me with bruises from her, he would kill her. He was a violent person, and she probably believed him. That put an end to the physical violence, but my mother continued the psychological violence for a long time after that. She turned her frustration and violence on my father and my half-sister. Once, she tried to stab my father with a kitchen knife in front of me. It was so traumatizing to sit there, in a wheelchair, and not be able to do anything. I believe my mother is schizophrenic, but she was never diagnosed; she always refused to look for help. She is still alive. We have no contact. Just the tone of her voice brings back horrible, painful memories. I don't want to see her ever again.

I wasn't the only one to endure physical abuse from my mother. My half-sister from my mother's first marriage was in first grade in elementary school. One day, she returned home with a bad grade, and our mother literally stabbed her with a knife. She was bleeding profusely, but the wound was not severe. Needless to say, both my sister and I were severely traumatized after that. There were so many episodes of violence, they were all at home, and they all went ››

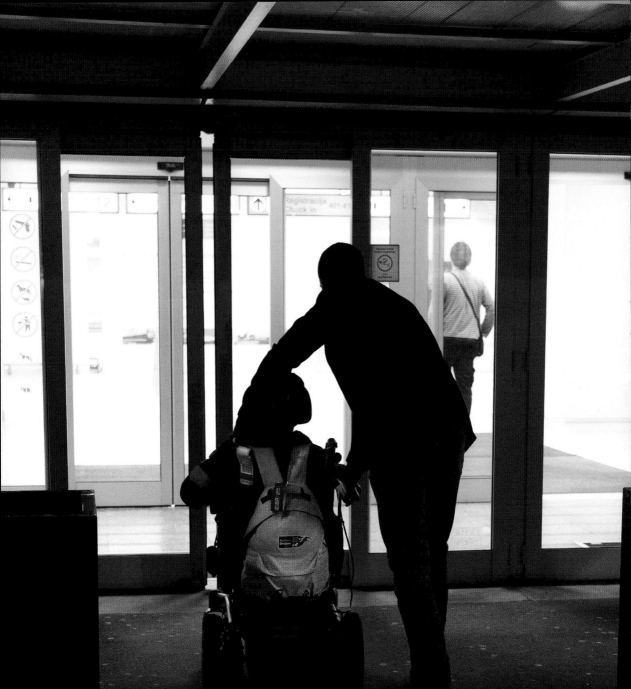

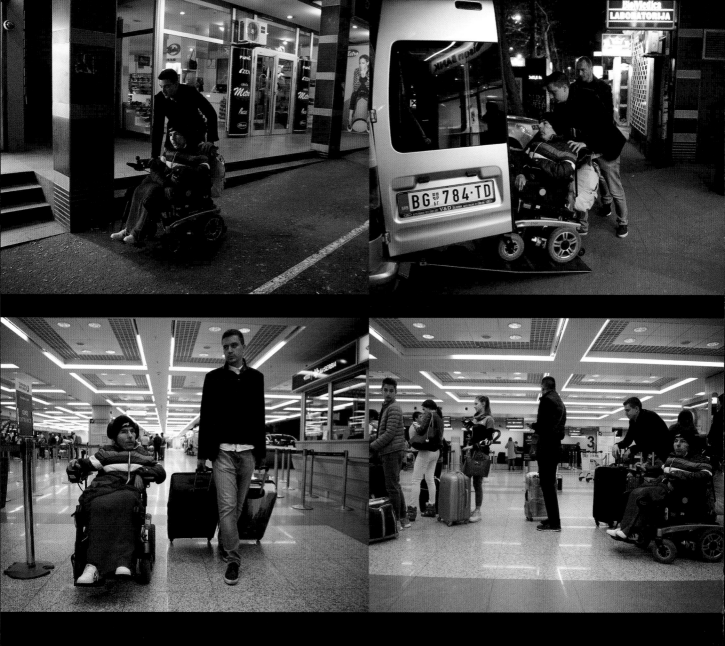

unpunished. No one knew, no one cared. There were so many times that I wished I was healthy and could walk, just so I could kill my mother. My mother denies that she ever stabbed my sister, but the scar is still there.

[Bojan Babić] I was twenty-one when I came out to my dad. He asked me why I was telling him "those things." My dad told me that he would have preferred not to know about "this thing," and that it would have been better for me to just get married to a woman and, if I really needed to, have secret relationships with men, "like most of the other

faggots." He loathed being aware of it.

[NM] That's quite typical, I'm afraid, for Serbia. I know so many people who are closeted, married, and in an extra-conjugal same-sex relationship. It's so sad for everyone involved. In these relationships, domestic violence is common; the darkest side of people comes to the surface, and the relationships generally don't end well. Most of the time, it's the wife that suffers the most.

[BB] My dad told me that it would have been better if my mom had had a miscarriage or abortion instead of having a son like me. He wished I had

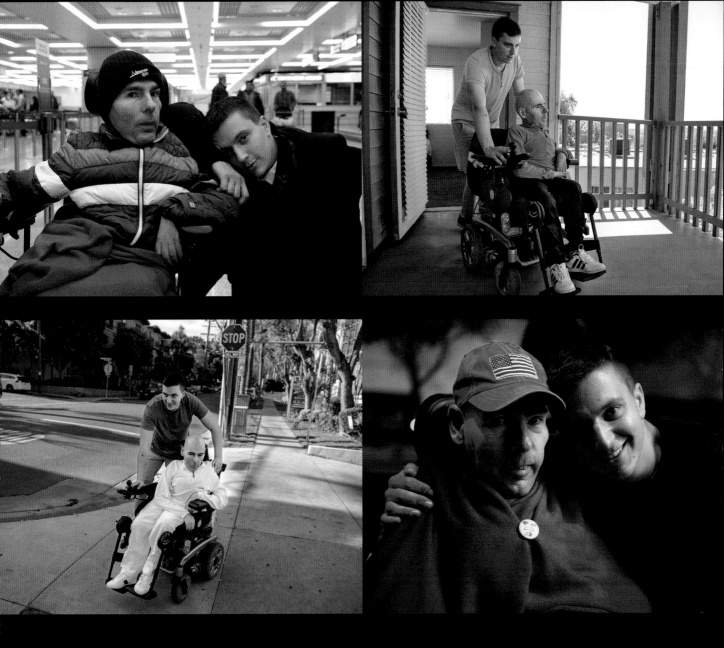

gone to conversion therapy. There're still doing it here. For example, in the Institute for Public Health in Palmotićeva Street. I interned there for a while. It's unofficial; you can't find those services in any published material. But while I was interning there, we were doing group therapy, and people were talking about issues, like alcoholism, drug abuse, and homosexuality. After the meetings, we would go to a professor and ask questions we couldn't answer ourselves. I was not out back then, and I was very curious about how they were handling gay people. The professor told us that there was a "treatment

therapy for gay people" and that they were "curing them." I wanted to know more. She said that since homosexuality was a result of psychosis, they would normally use anti-psychotics as a treatment. I asked her if she was aware that it was illegal in Serbia to treat homosexuality as a disease or mental disorder and that, according to the World Health Organization, homosexuality shouldn't be treated as such, and she started scrambling to explain how it was not her who was applying this therapy but some other doctors from her department. She was clearly uncomfortable and quickly changed the subject. ››

Nenad and Bojan shortly after their arrival in Los Angeles, heading to Venice Beach for the first time.

I was very curious to learn more about it, so I did some research online. I discovered a priest who was apparently successfully cured of homosexuality. He claims that it was that same Public Institute for Mental Health where he was treated. I'm clearly neither the first nor the last person who has heard these kinds of things. That happened four years ago, but I doubt that anything has changed since. We actually reported this to the Office for Human Rights, and they advised us that, even if we had a recording of those conversations in which doctors were openly talking about treating patients with conversion therapy, it would be illegal to use those recordings as evidence in court and we could get in trouble for recording them without their consent, so we just dropped the whole thing.

NM I was really tempted to go and get myself treated and see how far they would go and which methods they would use on me. Unfortunately, the current state of my health doesn't allow me to do it. They are ruining so many people, and I'm afraid that we can't even imagine what those people have to go through during conversion therapy. It's happening under our noses, and no one is doing anything to prevent it. It's sickening.

Gay people may have the same legal rights as other people, but they are not treated equally. That's a very important thing to understand. When people ask me why we are asking for special rights, I tell them, "Let us first be equal." People don't get it; they don't understand that LGBTQ people are not asking for any special rights—we literally only want to be treated in the same way as everyone else. It's as simple as that, but instead we are being constantly denied our right to exist the way we are. People tell me that marriage doesn't matter anymore, that it has lost its traditional value, that having children is overrated and complicated. I ask them, "If it's all so irrelevant, why did you get married and have children then?" It's because they can, and we can't. That's unfair and unacceptable.

Because of his interviews, Nenad received death threats—Bojan, too. They were afraid that someone might actually harm them, and they applied for asylum in the United States. They eventually moved to Los Angeles, not without a great deal of stress, especially because of Nenad's health. Once in Los

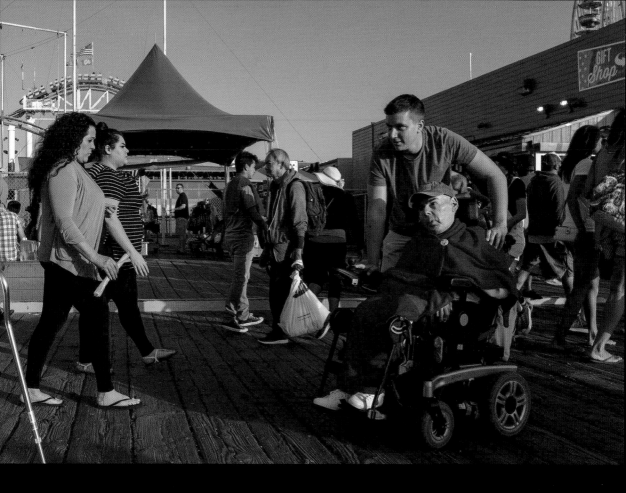

Angeles, they settled in a two bedroom apartment in West Hollywood.

BB I want to open a bakery here!

NM He loves baking, he's been talking about this bakery all the time. Meanwhile, we've been here five months already, Bojan has been nursing me every single day, without a break, because I require a huge amount of attention. He moves me every couple of hours because my body gets intolerably sore if I stay in the same position for a long time. He puts me on a respirator a couple of times a day. He cooks and feeds me—it takes about an hour for each meal because I choke easily. He takes me to the bathroom. He bathes me. I'd die if he left me alone for more than a few hours. He is literally my life support. Sometimes I feel like I've been stupid. How did I think we could embark on this adventure, with my health in the condition that it is? We left Serbia because we were receiving death threats. We were too afraid to go anywhere. We were, we joked, under voluntary house arrest.

I also feel imprisoned here. I can't leave the apartment because of the way the medical system and insurance companies work. My wheelchair

works one day and not the next, and because the street is so steep, I'm afraid to go outside. It's my old wheelchair, and it's made in Germany. They don't service this brand here so we can't find spare parts for it. We applied for a new wheelchair here, but the person who came to visit us determined I don't need an electric wheelchair—just the simple, mechanical wheelchair. We are mystified by her decision. She saw where we live, how steep the street is.

I imagined our life here would be very different. It seems like every door is closed to us, and no-one cares enough to really help us. It's disappointing and worrying. How is it possible that the system is so broken here that no one helps refugees and people with disabilities? It's not as if we're not trying hard enough, we're doing everything we can. Meanwhile, the monthly help we're receiving as refugees doesn't even cover the rent, we spent all our savings moving from Serbia to Los Angeles, and now we are living on borrowed money. We can't go on like this. In order for Bojan to have a full-time job, I need to have at least twelve hours of nursing here. If I had twelve hours, Bojan would have time to travel to and back from work and spend eight to ten hours on work. They assigned ››

"We left Serbia because we were receiving death threats. We were too afraid to go anywhere. We were, we joked, under voluntary house arrest."

me only seven hours of help a day. With seven hours Bojan barely has the time to work part time.

BB Nenad and I went to the Department of Rehabilitation and the Refugee Employment Program. At the Refugee Employment Program, Nenad was turned away because they said a person in his condition wasn't suitable for any kind of employment in California and he should stay at home and receive benefits instead of searching for a job. At the Department of Rehabilitation they told us that Nenad couldn't apply for a job because he wasn't proficient in English. We were so puzzled by the way we were treated. It seemed that no one was trying to really help us. People were doing only the minimum required, bouncing us from one place to another, burying us under unnecessary administrative complications and redundant requests. We were hoping that here in United States of America, things would be different. This was a dream for us, to be able to live in a democracy, to be treated with dignity, in a country of equal opportunity, the country where all men are created equal. It turns out that we were so wrong. We're becoming quite desperate and don't know what to do. We can't keep borrowing money for food and medical supplies.

NM The FDA has approved a treatment for spinal muscular atrophy that should stop the degenerative process. The side effects are insane but, in my case, it could have prevented my lungs from collapsing and it would have allowed me to breathe without a respirator. It could have allowed Bojan to leave me for longer periods of time. The problem is that the medication costs $375,000. No insurance company will cover it, especially not Medicaid. I had to give up trying to get it. It's medication for rich people. We are not rich.

BB We're even thinking of going back to Serbia. It's our last resort, but we're struggling. We're physically and mentally exhausted. ››

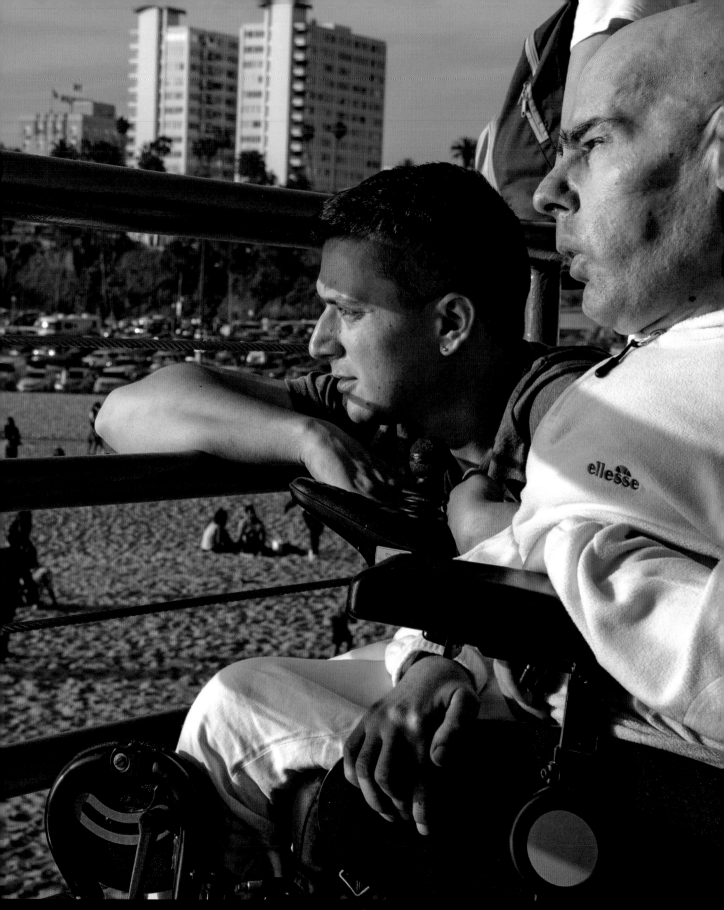

Gazing at the Pacific Ocean for the first time, full of dreams for a better life.

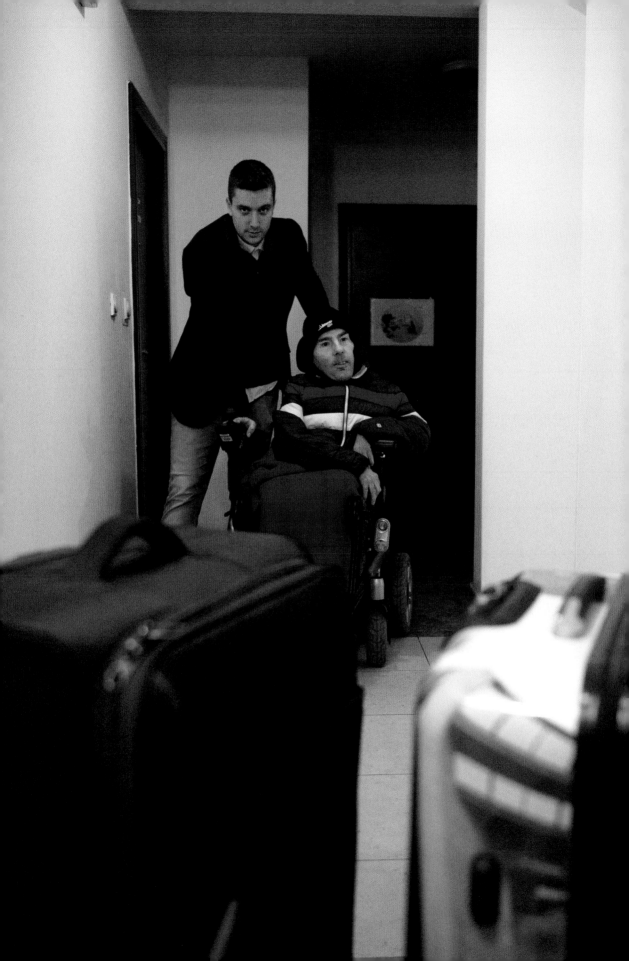

"Gay people may have the same legal rights as other people, but they are not treated equally."

NM We don't want to leave, we don't want to go back, but if it comes to that, we will have to.

BB And meanwhile, Nenad's biggest frustration comes from not being able to fit a piece of chocolate in his mouth.

NM Fitting big things in small holes is all about technique.

BB And patience! [they laugh]

A couple of months later, almost a full year after they left Belgrade, they were back in Serbia. We met briefly because Nenad's health was so bad, he couldn't see me for more than a few minutes. The fingers on his right hand had stopped working and he was now completely paralyzed; he couldn't even move his electric wheelchair anymore. He was having nightmares and anxiety attacks. He was in the process of waiting to see a doctor he believed could help him.

NM We spent about ten months in Los Angeles. It feels like a distant dream. Sometimes I feel stupid to have embarked on such an adventure with my health condition. It was all for nothing, and here we are back in Serbia, starting from zero; worse, below zero. You should see how our neighbors look at us here, as if to say, "Look who's back. How come?" When we left, we pretty much said goodbye forever to everyone, and we're back, impoverished, physically and mentally broken, afraid more than ever before, humiliated.

I feel terrible for what I'm putting Bojan through. He's a saint, an angel. He doesn't deserve to live like this, I feel terrible for doing this to him. He lost an opportunity to live a decent life in the United States. I took it away from him, and I can't forgive myself. Bojan is so young.

BB I haven't told my parents that I'm back. They will want to see me and would overwhelm me with questions, and I really don't want to see them. With Nenad being in this condition, I really don't have time and energy for family drama.

My parents are divorced and my dad remarried and has a son who's nine, maybe ten now. I don't really have much contact with him. He's a little close-minded and conservative. We had some issues with him in the past, so I try to avoid contact. He threatened us physically, told us that he will "break our bones." This was back in 2012. He hates gay people, and the fact that his son is "a faggot" isn't acceptable. One day, in front of the temple of St. Sava, he confronted us and asked me if Nenad and I were gay and if we were together. I responded with something like: "What if we were?" He got so enraged that he tried to physically assault us and threatened to kill us. I called the police. What I received in response was maybe even more shocking than my own father trying to beat the gay out of me. The police operator on the phone told me that they would not interfere in family affairs and that we should "figure out our family issues" ourselves. It was shocking.

NM I was so angry that I tried to stand up. Can you imagine? I just wanted to stand up and defend Bojan. It must have been comical for people who were watching.

BB After a couple of days my father apparently calmed down. His wife asked me to forgive him. I didn't. He's a boring person; he's like a broken record, keeps playing the same song over and over again. I don't really want to be around him. The farther I am from him, the better. ››

"We have each other and our dignity. We have nothing else left."

My mother is in her own world. She lives in the south, near Leskovac. I have a slightly better relationship with her, but the best relationship I have is with my grandmother. My grandmother is like a mother to me. She knows that I'm gay, and whatever that means to her, she's okay with it. Unlike pretty much everyone else in my family, she never asks me if I have a girlfriend and when I'm getting married. Sometimes, she tells stories about her husband that sound totally queer. Apparently, he always used to say, "Who would do her, I would do him." It's a weird saying, and I don't really know how to interpret it, but it sounds pretty gay to me.

I wish we felt safer than before, but people never stopped hating. Nenad might not be working, but the Internet never sleeps. We receive hate messages every single day, and some of them are personal threats. Most of them are under fake names, and it's impossible to trace them. The police don't really follow IP addresses; instead, they go to these peoples' Facebook profile photos and try to recognize them. Needless to say, that never works. I used to report hate messages more often. Now I don't do it anymore. It doesn't make any sense to do anything, because it never leads to anything. It's just a waste of my precious time.

NM We need to stop obsessing about it. At this point, we have no other choice but to embrace our reality for what it is and go with it. If I die, I die. If we get killed, we get killed. Hopefully it won't happen, but we have no power over it at this point. We refuse to live like prisoners anymore. I will not stop working and, the moment I get better, I am returning to work. I need to preserve my dignity no matter what. We have each other and our dignity. We have nothing else left.

"The only constant in life is change."

Irina Radošević & R.

"We're not asking for much. We're not asking for anything special. We don't want to be better than anyone else; we just want to be equal. We just want to be treated with dignity and feel safe."

Irina Radošević I had this brilliant idea a month ago: I stopped smoking. A couple of weeks later, instead of buying cigarettes, I bought a secondhand tent online. I found a nice spot in the woods near the river, pitched the tent, and one day, when Jovana was with her dad, I took R there as a surprise. She was blown away! We had the best weekend! It was like being teenagers again. We'd wake up really early, around six, watch the sunrise, and around seven I'd go to work. After work, I'd get a cup of coffee and sit on a folding chair in front of the tent and enjoy the sounds of nature. It was so beautiful.

Take a photo of R, and that's what love means to me. She epitomizes love for me. I desire her. I adore her. I worship her. I write love letters and poetry to her. I respect her. She is all I want. With her, I'm the luckiest woman in the world. She is love, period.

R We complement each other. We're so lucky to have each other.

IR R is such a sweetheart. I love receiving her silly texts. We go back and forth like teenagers. She texts me, "I love you"; I text her back, "I love you more." She responds, "muchisimo"; I say, "kisses, kisses, and more kisses." Last night, she slept in bed, I slept on the floor. We have terrible beds from the seventies. They're small, so one of us always ends up hanging half out. She woke up and saw me on the floor, she pulled me up, made some room for me, and said, "I love you so much." I said, "I love you more." Jovana, who at that point was awake, jumped over, hugged us, and said, "Me, too!" It was such a happy moment.

I got tired of having blue hair, so I let Jovana dye

one small part of my hair in pink. She was so excited! She's so adorable; I worship her!

R Jovana is such a sweetheart. She's a little cuddle bunny.

IR She looks like me, and not like her dad, fortunately. I was practically forced to marry her father. My parents discovered I was a lesbian when I was sixteen, and my mother flipped out. They sent me to conversion therapy. For a couple of years, I went through brainwashing, lecturing, blackmail, all sorts of psychological pressure. I considered it normal. I didn't know any better. That's what they wanted me to do; they kept telling me that it was for my own good, so I believed them and did what I was told. It was horrible. I don't know how I survived.

When I was old enough, my parents practically forced me to get married. I didn't really want to. The therapist brainwashed me into believing that I was something I wasn't, and those beliefs also pushed me into getting married. I started living a life I didn't want and didn't like. I was not myself. I felt imprisoned in my own existence, and I didn't know how to liberate myself. I was depressed, anxious, and anorexic; I weighed forty-five pounds less than I weigh today. I got to a point where every single time I heard my husband put his key in the lock of our main door, I would start having a panic attack. After sex, I'd go to the bathroom to cry or throw up. I hated having sex with him. He was older and didn't take no for an answer. He was a selfish lover and never paid any attention to me. I almost always felt violated by him, but he didn't care. All he wanted was a quick fuck and a pathetic orgasm.

Can you imagine me having sex with a man? Me? But it happened. I got pregnant and had a child. I wanted to divorce him, but I was terrified of him and of physical violence. He was beating me up severely, and I didn't have the courage to ask for a divorce or to run away. I was alone; I had no support system. Where could I go? The fear was paralyzing. After a couple of years of hell, I just couldn't keep living a life like that, so I left him and took Jovana with me.

My father tolerated me for a while. The moment I turned eighteen, his attitude toward me changed. He became more aggressive and intolerant. I try not to ›

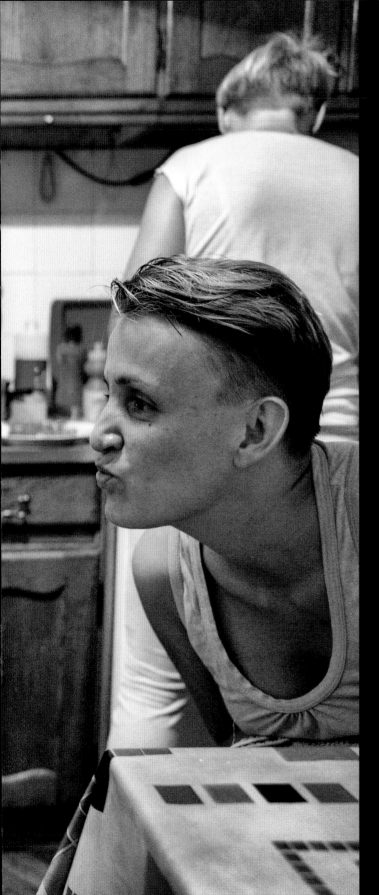

"I wish our relationship could be legally valid. I wish we could get married if we wanted to. I wish no one would hate us for just being who we are."

have anything to do with my mother. She is a horrible person, beyond exploitative. She's a little crazy. At some point, she made a series of bad decisions and was practically homeless and tried living with us. She was stealing from us, doing terrible things. She was all messed up, so we had to get rid of her. I bought her a tiny apartment so she could live there, and that was it. I don't want her in my life, as she brings so much negativity. I don't want my child around that woman.

Jovana said, "I have to go and see my dad, but I don't want to. How can he promise something and then break his promise, and I have to keep my promises every single time?" I told her, "It's because keeping promises is a reflection of who you are, and you're the kind of person who keeps promises." I asked her what kind of person she wanted to be, and she said, "A beautiful one." I think she's a beautiful person—she already is. In those silly moments, it really hits me how much I'm in love with R and how much I love my daughter. The feeling is so powerful, it's hard to describe. I would die for them without blinking an eye.

R My parents live in Novi Sad. They've been divorced since I was three years old. My dad's remarried. I have a younger half-brother, who's thirty now. When I call them, sometimes they answer. They never reach out to me, so we don't really have a relationship. I'm out to them, but I don't think the reason why they don't want to see me is because I'm a lesbian. They've always been like that, distant and just completely absent from my life. We still talk occasionally, but we're not close.

My brother is five years older than me. Our mom abandoned us. She just left us with her parents and left. My grandmother practically raised us. She died when I was eleven, and my brother was sixteen. After that, we were pretty much on our own. My dad had moved to a nearby village and remarried an older woman. My mom had started living a new life. ›

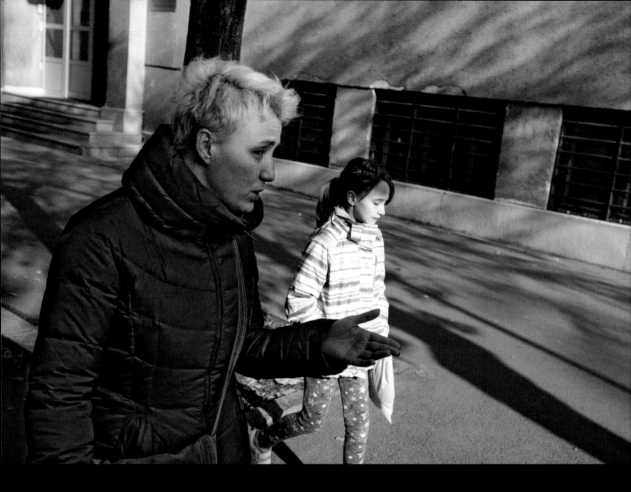

pretending that she had never been married and that she didn't have children. My brother and I were a big inconvenience for her, so it was easy for her to ditch us and forget that she even had children. She had her own apartment, where she lived as a single woman. She loved to play around, and she had many men, most of them briefly. I think she might have been a pro. She would visit occasionally, but not very often. My mom had serious mental health and self-esteem issues. She was always with abusive men who would call her names, tell her repeatedly how stupid she was, and even physically beat her up. Recently, my mom was actually diagnosed with a mental disorder, but she's refused to tell me what it is.

My brother always put his own interests above anyone else's. When my brother turned eighteen, he left. He managed to sell the apartment that my grandmother had left to me and him, and he took all the money. He got married and started a family. I never got my share. My family was always highly dysfunctional.

I never came out to my older brother. I told my mom maybe five years ago, but she won't accept it. She has serious mental health issues. I came

out to my dad over the phone just two months ago. He seemed to be okay with it. There was really no reaction, just his typical reaction, I would say. He doesn't care about anything to do with me or my life. I told him that I was planning to move to a different country, and he said, "Great!" and that was it. He has this guilt that he can't get over for not being in my life when I was growing up, and so now he just continues to ignore me. He was a severe alcoholic for many years. It's so sad. He was a terrible father.

The period after my grandmother's death was one of the most difficult periods of my life, when my mom came home. When my grandma died, I realized very clearly that I was on my own. I knew I couldn't rely on my parents, so there I was, an eleven-year-old me about to start taking care of myself the best way I could.

IR I have severe spinal compression in my vertebrae and some permanent neural damage in my hand. I've done some spinal steroid injections, but they exacerbate my carpal tunnel. You don't know how many nights I've spent crying from pain. It was absolutely awful, and it was driving me crazy. I don't know what to do with myself. I felt like I was falling apart, so no more steroid injections for me. I stopped

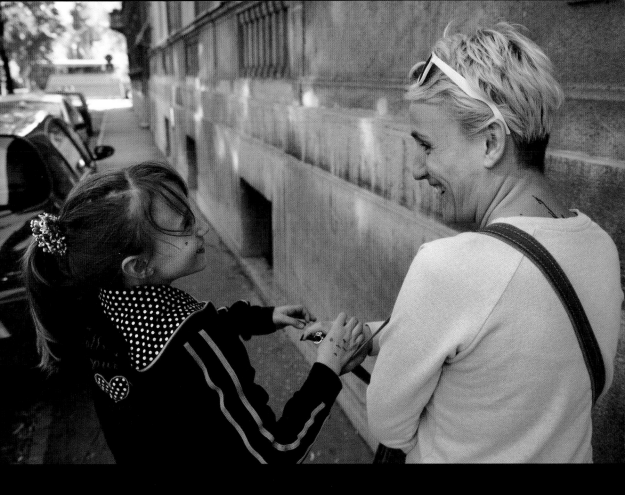

taking medication because I felt like it was making me feel even worse. I'm about to start with physical therapy and some meditation. I hope they make me feel better.

R At least she can walk now. Until recently, she was confined to bed. She couldn't get up or walk; it was pretty bad.

IR After that, I tried to go to a chiropractor, but the three I saw refused to treat me after they reviewed my x-rays and medical files. They said that it was too dangerous because of my current state.

I am thirty-three years old, and I've worked as a hair stylist my whole life. Now, I can't cut hair because of my shaking hands. I need to find a job as soon as possible. We can't survive on one salary. I'm willing to do anything. I can learn, but I don't know how to do things, so I don't even know how to start looking for a job. I can't even work as a secretary or an assistant because I've never done it and I'm clueless. I don't know how to use computers. For now, physical work is out of the question because of my health.

R There was a time when we had some cash saved and we looked at getting a loan from the bank. The problem was that I couldn't do it alone, because

I couldn't pay it off alone, and our union is not officially recognized—we are not officially a couple—so the bank wouldn't give us a loan. The system seems to be rigged to screw up poor people and especially poor lesbians and gays. If you're wealthy and you have connections, none of this matters.

IR I'm physically and psychologically in a terrible place, and I don't know how to get myself out. It's affecting R, and it's affecting Jovana. I know I have to kick myself out of this, but it's really hard because every day is a struggle.

R We're so sick of living like this. We can't keep living like this; it's not right—it's exhausting. We're not feeling well, and we're both getting depressed. It's so debilitating. We want to create a better future for our daughter. She deserves it. We don't want her to go through the hardships Irina and I went through. We want her to be able to succeed in life, but in order to do that, she has to be living in a healthy environment and have the possibility of getting a good education and more opportunities. Here, everything is limited, especially to people like us: we are no one, we don't have wealth, we are not ignorant, but we don't have great education, we don't have solid political ››

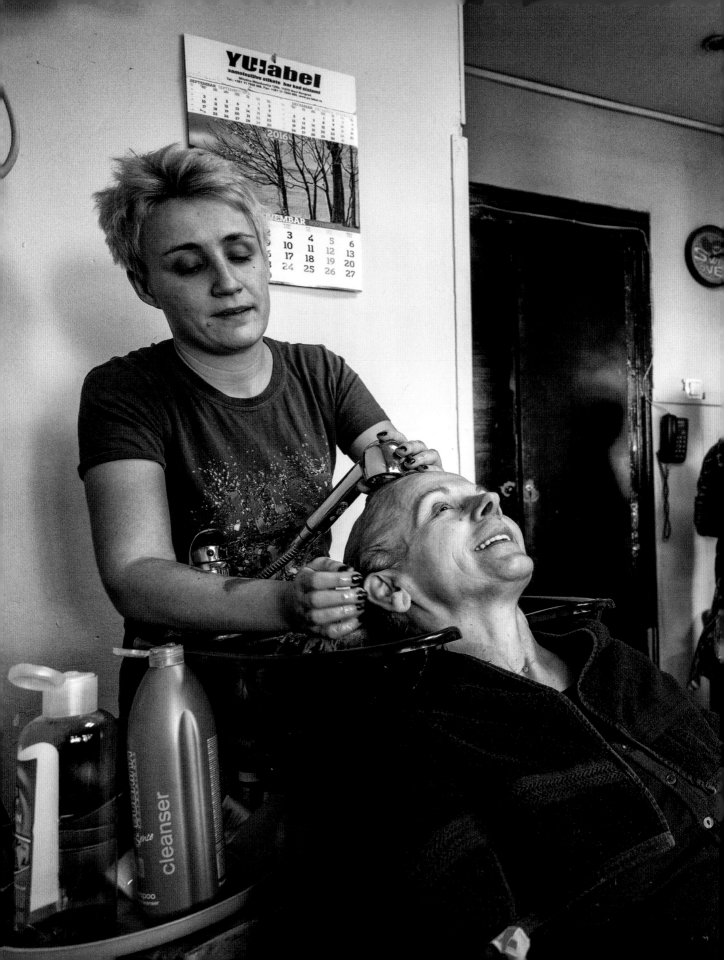

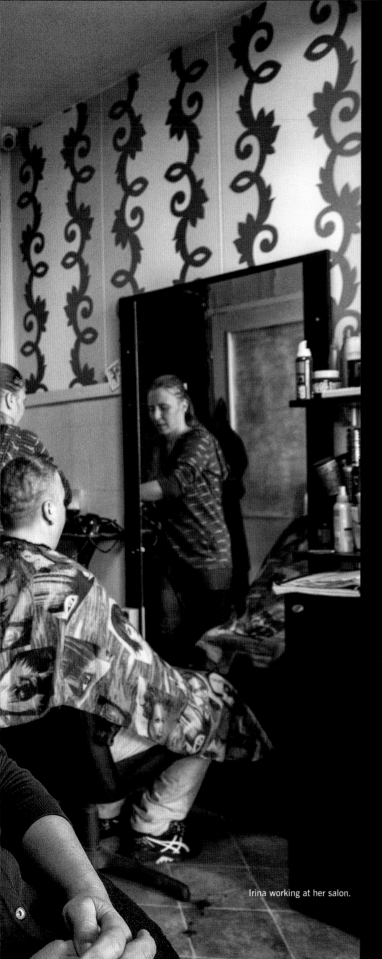

Irina working at her salon.

> **"I wish we didn't have to risk being beaten up in the street by some jerk who's annoyed by our intimacy."**

connections, we are not corrupt. We want Jovana to have a good life; it is our main priority.

We'd like to live in a country where we aren't under constant pressure to stay in the closet. I'm out to most of our friends here, but I'm not out at work. Because of the nature of my work, I'm absolutely certain that if I were to come out, I'd get fired. I need this job, and I need the money. We want to live somewhere where we can just be ourselves. We're good people—we care about each other and about others. We love our daughter so much and want to see her have more opportunities in life than we had. We're not asking for much. We're not asking for anything special. We don't want to be better than anyone else; we just want to be equal. We just want to be treated with dignity and feel safe. Here, that still seems impossible. People are still homophobic. That's why we're exploring going abroad.

IR I wish our relationship could be legally valid. I wish we could get married if we wanted to. I wish no one would hate us for just being who we are.

R I wish that, if one of us ended up in a hospital, we could visit each other as girlfriend or partner or wife, instead of lying and calling each other sisters. I wish we didn't have to risk being beaten up in the street by some jerk who's annoyed by our intimacy. Another reason why I want to move away from here is that I really want to have a baby. Here, it's practically impossible for a single mother—which I am officially here, since our relationship is not legalized—to have a baby through artificial insemination. I really want to have a child, and this dream could come true only in a foreign country, not here.

IR Norway has the best healthcare and employment opportunities. Plus they're very progressive when it comes to rights and benefits for same-sex couples.

R Unlike here. It's a little like the Wild West here. You don't really know who's doing what. The system is messed up. »

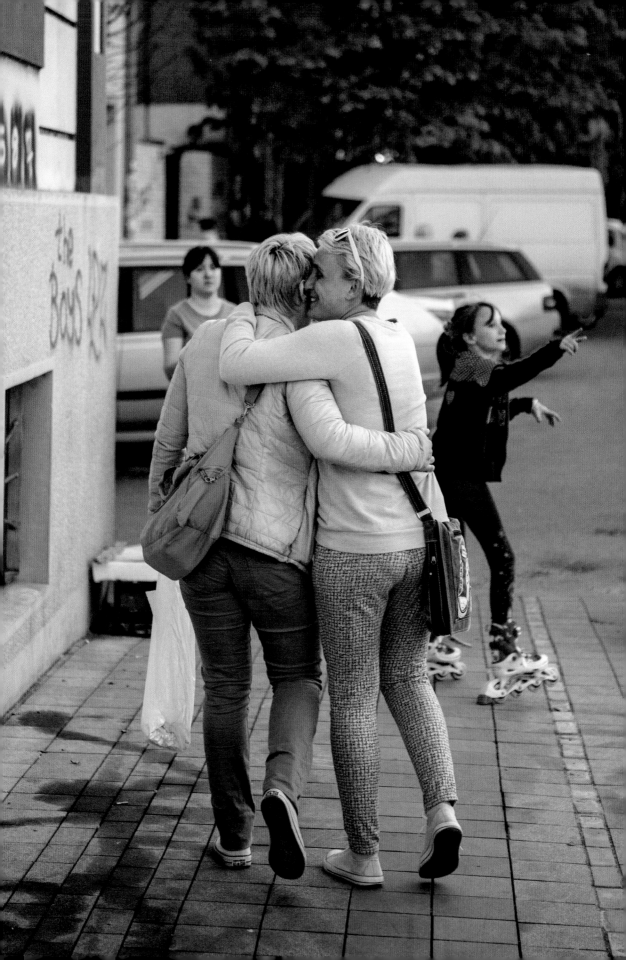

IR I'm sure that, if I were in Norway, when all these health issues happened to me, they would have figured it out. Here, I almost died after undergoing the wrong therapy. I've been bounced back and forth among hospitals, discharged each time without a clear diagnosis. It's terrible. No one knows what's wrong with me. In the meantime, my health keeps deteriorating, and I have no clue what to do and what not to do. I don't know, it's just very upsetting. It's one of the main reasons I wish we lived somewhere else.

R In this country, you just have to pray to not get sick, because if you do, you're in trouble. I regret not moving earlier. We both believed that Jovana should grow up with her father in her life. Both Irina and I didn't have a father growing up, so we didn't want to do the same thing to Jovana. She deserves to have a father in her life, one way or another, and we didn't want to jeopardize their relationship. Now, we feel the time has come to move on.

IR I share guardianship with her father. He has to consent for Jovana to go anywhere. I don't see a problem there.

R I'm sure Jovana's father would be very understanding.

IR Jovana is in a very weird phase. She is becoming quieter and not talkative and is refusing to communicate the way she used to. She's had some issues with her stepmother.

R She's so sensitive, but she keeps everything inside until she's totally overwhelmed and can't handle it anymore. Then she gets into this state and has breakdowns. I want her to sleep peacefully, to feel safe, to have beautiful dreams, not nightmares. She is eleven—she doesn't need this kind of stress. If we want a good future for her, we need to make sure she's safe and feels supported.

IR Since this thing has begun, her grades have gone down. She's moody, she talks back, she refuses to do things, she seems like a different person sometimes. Jovana who always said "yes" to everything is becoming Jovana who is saying "no" to many things. We're worried.

R She gets very upset when we try to talk to her about her behavior. When we try to confront her, she gets angry. It's so difficult to navigate these

relationships. I feel like our power reaches only so far.

IR I'm taking her to a counselor now. They provide counseling for kids with families with issues. They're a team of great people, and they really do a great job. They really care and are doing their best to counsel these kids.

R When things start going wrong, everything seems to start falling apart, a perfect storm. Currently, we seem to be in the middle of one. But all storms have to end, so hopefully we'll see the light soon. We're both looking forward to it.

IR I have a new tattoo. It's a phoenix rising from the ashes. It's not finished yet. I have a couple more sessions left. It's gorgeous, right? It took two six-hour sessions to complete one part. I probably need two more sessions to complete the whole thing. The girl who is doing it is quite amazing; she's an artist, a painter, but she also does tattoos. I really love it. The phoenix is a shape-shifter. It represents transformation, a transition from one state in life into another, a better state. It represents a cycle of life and its ever-changing conditions. You know, the only constant in life is change. I've been through so, so much in my life, and this tattoo represents it all. It's my life in transition toward something new, something better.

Acknowledgments

There is no way I can thank everyone by name. To all whose names and stories appear in these pages—Helena, Predrag, Dalibor, Srdjan, Saša, Marko, Aleksandra, Stefan, Štefica, Aleksandar, Sonja, Nenad, Bojan, Irina, and R—and to everyone I worked with, thank you from the bottom of my heart for accepting me into your lives, for trusting me throughout this process, and for sharing your reality. I wish you all the success and happiness in the world.

I have been incredibly privileged to have Jurek Wajdowicz and Lisa LaRochelle as my book designers and mentors during this process. Jurek, thank you for brilliantly and patiently guiding me through this process, for making me see things I would not have seen, and for making sense of things that didn't make sense to me. Thank you for your help and inspiration. Lisa, thank you for designing my book. I trusted your expertise and your judgment, and I am so happy I did! Thank you to the EWS design team for their steadfastness and support in the production of this book.

Ben Woodward, thank you for brilliantly editing the text and for making me look smart! Thanks, too, to the tireless work of Fran Forte and Emily Albarillo in the production team at The New Press.

No one inspired me more than Janet Mock. Early on, when I was full of doubt that I could ever return to Serbia and make this book, she told me she believed in me and made me believe in myself. I was so profoundly moved by Janet's second book, *Surpassing Certainty*, that I found my inspiration to write.

I would like to thank Aleksandra Pekić for making me keep my "letter" in the book. I had thought it might be too personal and was hesitant to include it, but she convinced me to keep it as is. Thank you for your friendship, Alex. This book gave me many gifts, and a very special one was you!

I would like to thank the people I photographed but who did not appear in the book. Unfortunately, due to the size of the book, some people could not be included. Yet their contributions were invaluable and each one of them helped me better understand the reality of LGBTQ people in Serbia.

Special thanks to Goran Miletić for introducing me to LGBTQ activism in Serbia.

Goran was my first contact in Belgrade, and his guidance and friendship were invaluable.

Also thanks to Helena Vuković. Without her this book would probably never have happened. I met Helena in a hospital the day after her gender-affirming procedure, and she generously gave me her trust and introduced me to countless people, some of whom appear in this book. Helena, thank you for your friendship.

There were times when I felt emotionally overwhelmed by the extraordinarily difficult things experienced by the people I met during this project, and my mother would magically appear in Belgrade, uninvited. Thank you, Mom, for always being there for me and for loving me the way you do. You are the best. Your love makes me a stronger and better person. You always were and always will be my hero and my inspiration. I worship you.

Dad, wherever you are, I hope you are proud of me. I miss you every day.

Finally, the greatest gratitude goes to my amazing husband, Jon, for his loving patience during my countless trips to Serbia. Thank you for understanding how important this book was for me and for always supporting me and pushing me to do more and to excel. Whenever I was in doubt, you always found a way to make me see things from a different, positive perspective. Your advice was invaluable. Without you, this book would never have happened, and I am grateful beyond words for your support. I love you.

This book series was made possible in part by a grant from the arcus FOUNDATION*

*The Arcus Foundation is a global foundation dedicated to the idea that people can live in harmony with one another and the natural world. The Foundation works to advance respect for diversity among peoples and in nature (www.ArcusFoundation.org).